John Richardson

MANET

PHAIDON

The author and publishers would like to thank all those museum authorities and private owners who have kindly allowed works in their possession to be reproduced.

Phaidon Press Limited, Littlegate House, St Ebbe's Street, Oxford
Published in the United States of America by E. P. Dutton & Co., Inc.

First published 1967
Second edition 1972
Third edition 1976

© *1976 Elsevier Publishing Projects SA, Lausanne/Smeets Illustrated Projects, Weert*

ISBN 0 7148 1743 0
Library of Congress Catalog Card Number: 67–29886

Printed in The Netherlands

MANET

Clarity, candour, urbanity and a virtuoso ability to handle paint – such are the qualities which first strike us in Manet's art. Here, we feel, is an *oeuvre* which raises no aesthetic problems and demands no special knowledge, which can be enjoyed effortlessly, for its own sake and on its own merits. And yet how wrong our first impressions are! For underneath its bland surface Manet's art abounds in pitfalls and contradictions, so much so that none of the writers who have tried to analyse it agree on the master's special qualities or failings, and his rightful place in the hierarchy of the great is still disputed. At various times, Edouard Manet has been described as 'a frightful realist' (Gautier) and as someone 'unfortunately marked by romanticism from birth' (Baudelaire); as the artist 'who opened up the age we call modern times' (Bataille); as 'a great painter for whom Impressionism was a deplorable aberration' (Roger Fry); as 'the most astonishing virtuoso of the modern school' (Colin) and as 'uninspired', 'mediocre' and 'mechanical' (Zervos); as a 'prince of visionaries' (Paul Mantz) and as 'totally without imagination' (Florisoone and others); as 'a revolutionary to end all revolutionaries' (Cochin), but also as 'nothing of a revolutionary, not even a rebel' (Colin) and as a '*sale bourgeois*' 'consumed by a vulgar ambition for "honours" ' (Clive Bell). Now, although some of these opinions are patently ridiculous, many undeniably contain a modicum of truth.

The task of reconciling the various anomalies and of distinguishing a coherent pattern in Manet's development is far from easy. It becomes possible, however, if we realize that there is a deep-seated dichotomy in Manet's character and that the artist, like the man, has more than a single face: he was both a devoted and domesticated husband as well as an impenitent *coureur*; a pious Catholic as well as a sceptical humanist; a gullible innocent as well as a cunning schemer; an ardent Socialist as well as a conforming bourgeois; a hard-working artist as well as an elegant *flâneur* 'who adored the *monde* and derived a secret thrill from the brilliant and scented delights of evening parties' (Zola). This does not mean that Manet was a hypocrite. He was intellectually too honest. Nor was he a schizophrenic, since his personality, though protean, was well integrated.

True, Manet aspired to be an officially recognized master like Ingres. He was proud of tracing his artistic lineage back to Giorgione and Titian, though no further – earlier European art was 'barbarous'. He was also one of the last great artists to work in terms of individual set-pieces rather than in series of variations on a given theme (like Degas, Monet and the Impressionists); and by the same token he persisted, unlike other independent artists, in submitting his works to official exhibitions, because, as he said, 'the Salon is the real field of battle. It is there that one must take one's measure.' To this extent he conformed to the pattern of the past. And yet Manet loathed academicism, partly because it falsified the image in the mirror which, he felt, art ought to hold up to contemporary life; and partly because he felt that the tradition of the old masters had ceased to be valid and that a new style based on a synthesis of old and new elements was needed. He succeeded because, like most of the greatest modern innovators – Monet, Van Gogh, Cézanne, Matisse, Picasso and Braque – he was primarily an artist,

not a theorist with preconceived notions of ideal beauty. In art the best results are achieved by intuitive rather than intellectual processes. Moreover, the synthesis of opposites which was at the root of his character helped Manet to fuse seemingly irreconcilable elements – taken from Daumier, the Spanish and Venetian masters, contemporary photographs and engravings, Frans Hals, Japanese wood-engravings and many other sources – into a viable modern style. It is thus a mistake to see Manet as 'the last of a race'. But is he 'the first of the moderns'? Here we must be careful to do full justice to Courbet, who was among the first to see that not only morally elevating subjects taken from history, legend or religion, but anything, no matter how humble and ordinary, is worthy of an artist's attention. This was to revolutionize the artist's approach to subject-matter, just as Manet's discoveries were to revolutionize the artist's approach to style. We should try to see Manet and Courbet together as twin begetters of the modern movement.

Manet's duality of temperament accounts for all kinds of paradoxes in his life, for instance a statement which he made in 1867 apropos an exhibition of some of his most controversial works: 'M. Manet has never wanted to make a protest . . . He claims neither to have overthrown the art of the past nor to have created a new order.' This, however, is exactly what he had done, but it would be a mistake to conclude that these words were insincere or disingenuous. They were dictated by the conformist side of his nature, by that side which aspired to official recognition and which – fortunately for his art – never managed to prevail. Not that Manet's conformist side was as black as it has been painted; the legend of the *sale bourgeois* who failed to live up to the genius thrust upon him by fate, dies hard. Far from being 'consumed by a vulgar ambition for "honours" . . . and praise', Manet could not bring himself to give his art a different look or make the concessions which officialdom expected of him. It is also too easily forgotten that Manet was an exceptionally cultivated and sensitive man with a profound knowledge of literature and music – is it not significant that he was the intimate friend of two of the greatest poets (Baudelaire and Mallarmé) of the century? – and that he came from one of those austerely high-minded and pious families which traditionally provided the French State with the most eminent of its public servants? From his father, a distinguished jurist, and his mother, an amateur musician, Manet inherited his judicial detachment, his sure taste, his moral courage, his sharp intelligence and the toughness of spirit that sustained him through eight years of intense. training and throughout his subsequent struggles. He also inherited from his parents a desire for conventional success, though there was nothing opportunist or self-seeking about this.

So much for Manet the conformist: now for the rebel. The fact that the artist was all his life a convinced left-wing Republican, a bitter enemy of the Second Empire and a firm friend of men like Gambetta, Jules Ferry and Zola, is usually passed over in silence. No doubt, the treatment meted out to Manet by the Emperor's artistic advisers strengthened his views; on the other hand, we must remember that, at the age of 16, he was already inveighing against the prospect of Napoleon's election and that he was deeply affected, as a youth, by the Revolutions of 1848 and 1851 – events which he experienced at first hand and even depicted. Because he disliked parading his private feelings, Manet's work seldom reflects his political convictions. There are, however, certain paintings which we cannot fully appreciate without taking them into consideration: notably *The Execution of the Emperor Maximilian of Mexico* (Plate 15).

Manet never made any secret of his political sympathies, so it is not surprising that during the Commune – like Corot, Courbet and Daumier – he was elected to the *Fédération des Artistes de Paris*. True, this occurred while Manet was absent from Paris and when he returned, during the last days of the Commune, he held aloof from the organization, because he was out of sympathy with extremist elements; however, a few drawings and lithographs of barricade scenes in a less detached vein than usual bear witness to his horror at the atrocities committed by the advancing army. After the Commune, Manet had hopes of expressing his liberal feelings in portraits of Victor Hugo and of his friend and hero Gambetta speaking in the Chambre des Députés, but the statesman was too busy to spare more than two sittings – both unproductive – and Manet complained to Proust that, although Gambetta was more advanced than most, Republicans were reactionaries when it came to art. With Henri Rochefort – the *communard* journalist who had made a sensational escape by boat from a penal colony – Manet had better luck: he persuaded him to sit for his portrait (Plate 43) and painted two pictures celebrating his exploit. That Manet should make a hero out of this notorious revolutionary was shocking enough; that he should then submit his portrait to the Salon of 1881 struck his friends as the act of a madman, since it nearly lost him the Salon medal and *Légion d'Honneur*, which he had always coveted. But it is characteristic of Manet that he did not play for safety in politics any more than in art.

Like his political opinions, Manet's revolutionary approach to art declared itself at an early date. He is said to have loathed school; even drawing-lessons, arranged by his kindly Uncle Fournier, bored him so much that he took to making caricatures instead of studies after plaster-casts and had to be expelled from the class. History paintings, which Manet was also expected to copy, struck him as absurd anachronisms and, while still at school, the boy announced that Diderot was talking nonsense when he maintained that an artist should not paint a man in contemporary dress: 'One must be of one's time,' said Manet, 'and paint what one sees.' Already in youth, he showed considerable strength of character. When his formidable father tried to force him to follow a legal career, he insisted on becoming a naval cadet and when, in 1850, he failed his naval exams, he persuaded his father to allow him to study art under Couture. The best description of Manet at this period is by Antonin Proust, a fellow-pupil in the same studio and the artist's lifelong friend. Manet, he says, was of 'medium height and muscular build. He had a lithe charm which was enhanced by the elegant swagger of his walk. No matter how much he exaggerated his gait or affected the drawl of a Parisian urchin, he was never in the least vulgar. One was conscious of his breeding . . .'

Manet's relationship with Couture is something of a mystery. Certainly it was uncomfortable, but it is difficult to believe that Manet had as much contempt for his master as he later claimed. For he not only studied under Couture for six years, but ended by developing a style based on that of his master, as for instance in the early *Portrait of Antonin Proust* (New York, Sachs Collection) and in *The Boy with the Cherries* (Lisbon, Gulbenkian Foundation), a pastiche that recalls, among much else, the study of a boy painted by Couture in 1846. The trouble was that Couture, who is too seldom given credit for his many liberal and anti-academic ideas, had an unreasoning hatred of realism, as witness his satirical painting of a student drawing a pig's snout (*The Realist*; New York, ex Coll. Vanderbilt). Now Manet, who admired his master up to a point, sincerely believed that Couture would eventually come round to accepting the realist vision, and it was not until

1859, when he submitted *The Absinthe Drinker* (Plate 1), his first truly realist painting, for Couture's approval that he suddenly realized his great mistake. 'There is only one absinthe drinker here,' was Couture's comment, 'the painter who perpetrated this madness.'

The Absinthe Drinker was both the cause of Manet's final rift with Couture and the occasion of his first brush with officialdom, for it was rejected by the Salon jury in 1859. This was a further blow to Manet, who made up his mind to choose a less controversial subject for the next exhibition. In the winter of 1860–1 Manet embarked on a large composition of a nude in a landscape (there is a preliminary sketch in the National Gallery, Oslo) based on an engraving by Vorsterman after Rubens. Although apparently destined for the Salon, this canvas did not in the end please the artist, who abandoned it and sent instead two paintings which he had completed earlier in the year: the portrait of his parents and *The Spanish Singer* (New York, Metropolitan Museum of Art). To Manet's great delight, both paintings were accepted by the jury, *The Spanish Singer* was awarded a medal (2nd class) and it was sufficiently well received by the critics for the artist to imagine that he had begun to make his reputation.

Surprisingly, no critic seems to have detected Manet's one stylistic innovation – the elimination of half-tones – which justifies us in regarding *The Spanish Singer*, and, to a lesser extent, the double portrait as sign-posts for the future development of nineteenth-century art. Instead of being steeped in the ochreous, old-masterish – or, as Manet called it, 'gravy-like' – penumbra common to most Salon exhibits, this onion-eating, wine-swigging guitarist is bathed in a harsh, flat light which makes him startlingly real. By exploding the fallacy of half-tones keyed to a *nuance dominante*, Manet established the artist's right to paint in whatever colours or tonalities he liked and thus enormously facilitated the development of Impressionism and much subsequent art. Small wonder that by the end of 1861 Manet found himself surrounded by a small but enthusiastic band of young artists – Legros, Carolus-Duran and Fantin-Latour among others – who looked up to him as a new master!

1862 is a crucial year for Manet's development. In a bid to consolidate his success of 1861, the thirty-year-old artist embarked on a series of ambitious paintings. According to Tabarant, the first of these is the large *The Old Musician* (Plate 4), a set-piece inspired by Velazquez' *Topers*, which Manet had not yet seen but which he knew at second-hand from Goya's engraving. Despite the rich, fresh beauty of its paint, *The Old Musician* is not altogether successful, for it is evidently pieced together out of separate studies. There seems to be no spatial, temporal or compositional, let alone thematic, relationship between the figures. These faults recur in many of Manet's works of the 1860s, and for a reason that is not hard to find: Manet's sense of design was faulty. Now instead of disguising this weakness, as a less independent artist might have done, by making judicious use of the compositional formulae taught in art schools, Manet repeatedly drew attention to it by dispensing with all but the most summary indications of perspective and by trying to reproduce on his canvas the informal – or, as he called them, 'naïve' – groupings of everyday life. This was courageous, but a number of his figure-compositions – especially those, like *The Old Musician*, consisting of a row of casually placed figures – disintegrate. As a result, the spatial illusion is often flawed by a further habitual weakness, an erratic sense of scale: e.g. the disproportionate woman in the background of *The Picnic* (Plate 2), the minuscule boy in the foreground of *View of the International Exhibition* (Oslo, National Gallery) and the gigantic man with the sunshade in

On the Beach at Boulogne (London, ex Pleydell-Bouverie Collection). True, Manet was a tremendously spontaneous painter who 'hurled himself on his bare canvas in a rush, as if he had never painted before' (Mallarmé); hence the freshness and unlaboured virtuosity of so many passages in his paintings, hence the clumsiness and shortcomings of others. But even when he took the precaution of making preliminary sketches, he was apt to end up with a poorly articulated design, especially if the composition involves a degree of recession or includes two or more isolated figures or groups.

Further examples of Manet's compositional difficulties are easily found, but this discussion of them may well end with a look at a large figure painting, of a Spanish subject and of 1862. The composition of *Lola de Valence* (Plate 7) is wholly successful; the pose, of course, derives from Goya and the setting has been taken over from a Daumier lithograph (*Dire . . . que dans mon temps, moi aussi, j'ai été une brillante Espagnole . . .* of 1857); but the different elements are perfectly adjusted and the scenery is cleverly used to enhance the back-stage reality as opposed to the romantic illusionism of the theatre.

Manet, the reader must by now have gathered, was a fervent Hispanophile and, in this respect, typical of his period. *Hispagnolisme* – the fashion for things Spanish – had started with Romantic poets and writers like Gautier, Mérimée and Hugo, and by the end of the 1830s had become a popular craze. By 1848, however, it was waning and might soon have died out if, in 1853, the Emperor had not married a Spanish beauty and thereby given it a new lease of life. Such facts as these are not irrelevant, for Manet was inordinately sensitive to fluctuations in fashion. But at the same time we must reckon with the possibility – or, to my mind, the probability – that Manet's *Hispagnolisme* also had its origins in a first-hand experience of Spanish art.

The few works surviving from Manet's student days are mostly copies after the old masters, so we cannot be sure when the Spanish influence first manifested itself. Certain it is, however, that at the end of the 1850s, when the artist was breaking with Couture, he turned to Goya and Velazquez for help in the formation of his new style. Now it is not altogether a coincidence that Spanish mannerisms appear so frequently in Manet's art at this time, for in 1859 a series of Goya's engravings was published which greatly impressed Baudelaire and his friends, Manet among them. Partly under the influence of these, Manet painted *The Spanish Singer* and a number of engravings in a Goyesque manner. I also suspect that the sharp contrasts of white and black, which he so much admired in Goya's graphic work, proved helpful to Manet in ridding his palette of half-tones. Velazquez was less easy to study in the Paris of 1860; nevertheless, Manet made paintings, drawings and engravings after various works then labelled Velazquez in the Louvre, notably the *Portrait of the Infanta Margareta* and the small *A Group of Thirteen Cavaliers*. At the same time he also painted two *Hommage to Velazquez*, imaginary scenes depicting the Spanish master and his models; and when in 1862 the Louvre purchased a *Portrait of Philip IV* Manet did a drawing and an engraving after it.

Manet's style, as well as his subject-matter, was deeply influenced by *Hispagnolisme*, especially by the various Spanish performers whom he saw at theatres and music halls in the early 1860s. In the same way, when a *cartel* of bull-fighters arrived in Paris in 1863, Manet made a point of getting them to come to his studio. The result is *The 'Posada'*, a group of toreadors in a tavern preparing for a bull-fight.

Once again, as in *A Group of Thirteen Cavaliers*, the figures – more than a dozen of them – are disposed in a frieze-like manner, and once again the composition does not altogether cohere, although this gives it a certain life-like awkwardness.

Manet's *Hispagnolisme* has been examined at some length, because it was largely responsible for transforming him from a brilliant student into a mature and original artist. By soaking himself in the work of the Spanish masters, Manet learnt how to condense and simplify his pictorial effects, how to produce natural groupings and attitudes, how to use blacks and greys as active colours and how to apply paint in a rich, loose and liquid manner far removed from the dry and costive *touche* advocated by Couture. And by learning how to paint Spanish subjects from life without relying on picturesque, romantic or exotic effects, Manet developed the straightforward, detached approach of the 'Peintre de la vie moderne', a role in which he made some of his most impressive artistic contributions in the early 1860s and particularly in the late 1870s.

When Baudelaire evolved the conception of the 'Peintre de la vie moderne' – the artist who would 'extract from fashion whatever poetry it might contain' and separate 'the eternal from the transitory' – he had Constantin Guys in mind. But his famous article applies just as well to Manet who was already a close friend of the poet's before 1860. Baudelaire defined 'the painter of modern life' as a dandy, a stroller who mixes with the crowd, watches the world go by, is in the midst of things and yet, as a personality, remains hidden. He envisaged a man with a natural curiosity about life who was anxious to appreciate everything going on around him, but content to stand on the periphery and remain impartial. Is this not precisely what Manet aspired to be? It is certainly an exact description of his attitude, when in 1862 he executed his first great scene of contemporary life, *Music in the Tuileries Gardens* (Plate 5) – a picture of prime importance for the development not only of Manet's *oeuvre* but of modern French art. True, as has frequently been pointed out, it is derivative in composition, for it recalls eighteenth-century *études de moeurs* by Saint-Aubin and Debucourt and also has affinities with a lithograph by Daumier and with scenes of Parisian life by Guys and other draughtsmen who worked for illustrated papers. But in every other respect it is original: it is the first out-of-doors scene (as opposed to a straightforward nature study) which is entirely convincing as such; it is the first important French painting to sacrifice 'finish' and 'detail' to the general impression of an animated scene; it is the first record of nineteenth-century bourgeois life that is detached, realistic and seemingly spontaneous while yet being a work of art; indeed, it has quite a claim to be the first truly modern picture, at any rate in Baudelaire's sense of the word 'modern'. Here we find none of the prettification or fashion-plate triviality which detract from comparable subjects by Isabey or Lami, nor – at the other extreme – the studio stuffiness or heavy-handed social comment which sometimes mar Courbet's realistic evocations of rural life. *Music in the Tuileries Gardens* celebrates no particular incident. It is a literal record of everyday life, and it was this fact which provoked an uproar when it was exhibited. The 'slapdash' manner of its execution was bad enough, but what most irritated the Parisians was to see themselves depicted informally, as they really were.

For much the same reasons the public attacked Manet's other key-picture of 1862, *The Street Singer* (Plate 6), which depicts a drab-looking Parisian street singer emerging from a low tavern. Had there been a touch of pathos in the treatment of the subject, the public might have overlooked its ordinariness. But there is nothing

sentimental or anecdotal about it; worse, as Paul Mantz pointed out, 'there is nothing more here than the shattering discord of chalky tones with black ones. The effect is pallid, harsh, ominous.' Manet's abandonment of half-tones was of course partly to blame for this 'shattering discord', but we must also consider another element which creeps into his style at this time: the influence of Japanese prints. Look, for instance, at the way the street singer is reduced to a sort of bell-shaped cut-out, her dress being treated as an almost two-dimensional surface on which trimmings and folds form a bold, linear pattern, as in an Utamaro or a Hokusai. In *The Street Singer* the *japonnerie* is still rudimentary, but in subsequent works – *Olympia* (Plate 3) and *The Fifer* (Plate 16), for example – it becomes a dominant stylistic ingredient. However, Manet always makes such discreet use of *japonnerie*, blending it with elements from Spanish and Venetian art and even from *images d'Epinal*, that one seldom realizes what an active role it plays. For instance, at first sight, the *Portrait of Emile Zola* (Plate 19) seems to owe its conception to Venetian art; and yet, when closely studied, this canvas proves to be based on a decorative arrangement of flattened, vari-coloured forms such as one sees in the print by Utamaro in the background. Definite traces of Japanese influence are likewise to be found in the treatment of the negress and the setting of *Olympia*, in the right-hand figure in *The Balcony* (Plate 13), in *The Lady with the Fans* (Paris, Louvre) and in many later pictures.

Manet was not the first nineteenth-century painter, of course, to discover or to exploit the stylistic possibilities of Japanese art. On the contrary, *japonnerie* had been in fashion with a restricted *avant-garde* circle since the mid-1850s when Félix Bracquemond (the engraver), the Goncourts and, a little later, Baudelaire had started to popularize Japanese wood-engravings. When Manet was forming his style, *japonnerie*, like *Hispagnolisme*, was in the air. Through studying Japanese prints, Manet learnt how to flatten his forms, how to simplify his spatial notation, how to dispense with a perspectival continuum, how to arrive at a rhythmic, linear structure and how to give his 'naïve' compositions a measure of decorative unity. Manet's imaginative exploitation of *japonnerie* is of the utmost importance for the subsequent development of nineteenth-century art, for it revealed to Degas, the Impressionists and post-Impressionists (notably Gauguin, Toulouse-Lautrec and Van Gogh) a convenient escape route from the academic *impasse* in which European art was trapped.

Japonnerie and *Hispagnolisme* were not the only mid-century phenomena to influence Manet's style; the camera also plays an important role. Here again Manet gives evidence of his perception and originality. Most artists of the period, as Baudelaire complained, were trying to pit their puny resources against the new invention by attempting to produce pictures as accurate and detailed as photographs. On the other hand, Manet, himself an expert amateur photographer, realized that there was no call for the artist to sell out to Daguerre, because the camera obviated the need for excessive representationalism. Moreover he saw that he could learn a great deal from the way in which the impartial eye of the camera recorded things as they really were, and in sharp contrasts of black and white. Like Degas, Manet occasionally worked from photographs; and he may also have made some use of photographs when working on likenesses of various friends and celebrities in *Music in the Tuileries Gardens*. But the most significant, at the same time most elusive, manifestation of the camera's influence on Manet's vision is to be found in the frozen, naturalistic poses and 'dead-pan' expressions – so redolent of the photographer's studio – which are characteristic of virtually all his portraits and

figure-paintings done before 1870: for example those in *The Picnic* (Plate 2) and *Luncheon in the Studio* (Plate 21). What are these models staring at so intently, yet so vacantly? Not the artist, one feels, but Nadar's 'magic box'. And why this mask-like impassivity? Here Manet's Baudelairean cult of dandyism provides the answer. A dispassionate approach allowed Manet to capture 'the character of a dandy's beauty', which according to Baudelaire, 'lies in the coldness of the gaze, the outward expression of an unshakeable resolution not to be moved. One could compare it to a dormant fire whose existence we can only guess at, for it refuses to burst into flame. This [Baudelaire was actually referring to Guys, but these words are more applicable to Manet] is what these pictures express to perfection.'

By the end of 1862 Manet had every reason to feel satisfied: in one year he had completed over a dozen major and numerous minor works, had managed to transform his hesitant manner into a strong, supple and personal style and, no less important, had discovered how to express on canvas the life of his native city and of his own time. Not unnaturally he was eager to exhibit what he had done as soon as possible, so as to prove that he was no longer a promising beginner; consequently fourteen of his best paintings were put on show at the Galerie Martinet at the beginning of March 1863. Manet hoped that they would enjoy such popular success that the Salon jurors would unhesitatingly accept three others which he proposed to submit to them later in the spring. But his optimism was as usual misplaced and his one-man show – an innovation to which the public was not as yet accustomed – was received with vituperative abuse by all but a minority of critics and a few young painters (Monet and Bazille among them). One visitor even threatened to attack *Music in the Tuileries Gardens* with his walking stick. Worse was to come; Manet's three Salon entries – *Young Man in the Costume of a 'Mayo'*, the *Mlle Victorine in the Costume of an Espada* and *The Picnic* (Plate 2) – were rejected. With good reason Manet protested; nor was he the only artist to do so. More than 4,000 works were refused by the Salon jury that year, including paintings by Cézanne, Whistler, Pissarro, Fantin-Latour and Jongkind, and the ensuing complaints were so loud and numerous that the Emperor was forced to take notice of them. More out of a desire to prove the Salon jury right than out of any desire to display his own liberal feelings, the Emperor decreed that all the rejected pictures should be exhibited together in the Palais de l'Industrie. Manet, who seldom despaired for long, welcomed this opportunity of displaying his work, but once again his hopes were to be shattered. The public and critics (except for Zacharie Astruc and Thoré-Bürger) were in no mood to be lenient to the *Salon des Refusés*, as the exhibition came to be known; and while they jeered at everything, they singled out Manet's work, especially *The Picnic*, for their scorn.

Little is to be gained by quoting at length from the journalistic attacks on Manet beyond the insight which they afford into the depths of Second Empire philistinism. For Manet's persecutors were on the whole ill-informed and obtuse, and their invective casts darkness rather than light on his achievements. So far as one can see, what most shocked people about *The Picnic* was that it treated a *risqué* subject seriously. Had Manet presented his picnic as a titillating *scène galante*, had he treated it in an idyllic or pastoral instead of a modern manner, or had he dressed up the men in doublet and hose and given his composition a high-falutin' poetic title, the public might have been less incensed. What they could not stomach was the naturalism of the conception, the absence of anecdotal detail and sentiment, and

the fact that light, instead of being conventionally golden, is clear, cool and shines equally on the whole scene instead of being artfully used to pick out pretty passages.

Had Manet really been (as Paul Colin and others have maintained) a cowardly traditionalist, he would presumably have heeded his critics and adjusted his style. But much as he longed for recognition and popularity at this time, Manet made no concessions to bourgeois taste and continued in a more, rather than a less, revolutionary way. After finishing *The Picnic*, he embarked on *Olympia* (Plate 3), the work which the artist always considered as his masterpiece. And rightly so, for it is a triumphant proof of the power and originality of the style which Manet had arrived at by a laborious process of synthesis, a style which anticipates much of the best twentieth-century art in being based on conceptual rather than perceptual elements. *Olympia* is a tremendous advance on *The Picnic* painted only a few months before. Forms are more ruthlessly flattened and simplified and the main *motif* of the picture – the figure, the bed, the bouquet and the maid (or rather her dress) – is restricted to a lightly modelled, lightly coloured mass silhouetted against a dark background. And yet, despite its seeming flatness, *Olympia* evokes a sensation of volume, thanks to a few cunningly placed shadows, to the subtle suggestion of an outline (one of Manet's most criticized innovations, and yet what could be more orthodoxly classical?) and to the heavy impasto of cream-coloured paint, which gives to the girl's body a marvellous tactile quality and fleshy density. *Olympia* has become so hackneyed that its beauties are difficult to appreciate today but, to my mind, no amount of reproductions can stale its radiance or its freshness.

What did Manet think would happen when he exhibited *Olympia* at the Salon of 1865? Admittedly he was somewhat naïve, but still he cannot have been so naïve as to imagine that the style and subject of his latest picture were anything other than provocative. 'A yellow-bellied courtesan', *Olympia* was called, 'a female gorilla made of india-rubber outlined in black'. Even Courbet, hitherto a partisan of Manet's, is said to have compared her to 'the Queen of Spades after her bath'. When words failed, physical attacks were made on the picture, which was only saved by being hung out of reach above a door in the last gallery, 'where you scarcely knew whether you were looking at a parcel of nude flesh or a bundle of laundry'. Nevertheless, as Paul de Saint-Victor wrote, the mob continued 'to crowd round Manet's gamey *Olympia* and disgusting *Ecce Homo* as if they were at the morgue'.

As with *The Picnic*, it was not only the stylistic innovations of *Olympia* which infuriated people, but the 'shamelessness', 'immorality' and 'vulgarity' of the subject. Here was a naked girl, whom anybody could recognize (one of the few nudes in art of which this can be said), not an anonymous nude masquerading as a Circassian slave, coquettish Bathsheba, simpering nymph or frigid, ideal beauty. *Olympia* reclines – appropriately enough – on a bed and receives from her black maid a bouquet, a tribute to her charms. Now the Salon public was partial to *risqué* subjects, so long as the real action was disguised by some polite convention, that is to say dressed up as allegory or presented as a castigation of sin. Manet, however, was too much of a dandy to dissemble or moralize, and his *demi-mondaine* is portrayed with characteristic detachment – naked, unabashed (the critics of course said 'brazen') and unmistakably a Parisienne of her time; just the sort of Parisienne, indeed, that many a Salon visitor kept hidden from his wife. All this so scandalized people that by the time the Salon closed Manet's notoriety, said Degas, had become 'as great as Garibaldi's'; in fact, it had attained such proportions that instead

of 'enjoying the arrogant satisfaction of not being astonished', Manet discovered that he had become the unenviable butt of public ridicule. At this point he lost confidence and found himself unable to go on painting, and fled to Spain.

Manet's visit to Spain was both a revelation and a disappointment: a revelation because the Spanish masters exceeded his highest hopes and the spectacle of Spanish life delighted him; a disappointment because the dirt and bad food revolted this most fastidious of men. Had Manet been in a less discouraged state, curiosity might have triumphed over disgust. As it was, he did not stay longer than ten days in Madrid – enough time to develop a taste for bull-fighting and to discover that, while Goya did not live up to his expectations, Velazquez was 'the painter of painters'. 'The most extraordinary work of this splendid *oeuvre* (Manet wrote to Fantin-Latour) and perhaps the most astonishing painting ever done is the *Portrait of a Celebrated Actor of the Time of Philip IV*. The background disappears; the life-like figure dressed in black is surrounded by nothing but air . . . And what magnificent portraits! By contrast, Titian's *Charles V* seems made of wood.'

The outcome of this first-hand experience of Velazquez' work was a second phase of intense *Hispagnolisme*. The figure of *The Tragic Actor* (New York, Coll. Vanderbilt), which Manet painted after his return to Paris, is strongly reminiscent of the *Pablillos* and is steeped in the same airy, greyish element; while the two *Philosophers* (1865) and the *Rag-and-Bone-Man* (New York, Wildenstein) – large, full-length character studies of old men against plain, darkish backgrounds – are directly inspired by Velazquez' *Aesop* and *Menippus* (both Madrid, Prado). Indeed, it is difficult not to feel that these interpretations of Velazquez are almost too literal; even their qualities – impressive old-masterish ones – remind us that they are among the few works by Manet which derive not from real life but from art. However, not all the paintings inspired by Manet's Spanish visit were so unoriginal. Three magnificent bull-fighting scenes, started in October 1865, are entirely free of Velazquez' influence, being detached and naturalistic records, not vehicles for stylistic experiment, like so many other works of this phase. True, Manet has refreshed his memory by looking at Goya's *Tauromaquia* as well as at his own notes made in Madrid, but the vividness of these paintings bears out their origins in visual experience; and their naturalistic, seemingly casual compositions are much more satisfactory than those which Manet would have used before his Spanish journeys (Plate 14).

Much the same stylistic process can be followed if we compare the two works which Manet submitted, without success, to the Salon of 1866: *The Tragic Actor*, painted in the autumn of 1865, and *The Fifer* (Plate 16) of about six months later. Both paintings derive from Velazquez' *Pablillos*, in that both show figures 'surrounded by nothing but air'. But whereas the former only just escapes being pastiche, *The Fifer* is a triumphantly original and daring synthesis of Spanish and Japanese elements – an advance even on *Olympia*. From Velazquez Manet has learnt how to conjure up an illusion of space out of an unrelieved expanse of grey paint and a slight shadow (behind the right foot), while from the Japanese he has learnt how to arrive at a simple, but expressive and harmonious arrangement of flattish forms. Among Manet's contemporaries, Zola was almost alone in seeing what the artist was aiming at: 'One of our great modern landscape-painters,' he wrote, 'has said that this painting resembles an outfitter's signboard; I agree with him if he means by this that the boy's uniform has been treated with the simplicity of a popular print. The yellow of the braid, the blue-black of the tunic and the red of the trousers are just flat patches of colour. The simplification produced by the acute

and perceptive eye of the artist has resulted in a canvas, all lightness and *naïveté*, charming to the point of elegance, yet realistic to the point of ruggedness.'

The harmony, clarity, economy and concentration on essentials which we find in *The Fifer* are features of all Manet's best paintings, but more particularly of those done before 1869. Take, for instance, *The Execution of the Emperor Maximilian of Mexico* (Plate 15): how complex the incident Manet has chosen to depict, how concise the configuration! Yet the story is told dramatically, without rhetoric but with considerable pictorial effect. Likewise *Luncheon in the Studio* (Plate 21) of the following year; this is one of Manet's most complex compositions, but it is rendered with such simplicity (the cat, for instance, is reduced to a sort of black hieroglyph) that it appears wonderfully fresh and life-like. By contrast, a much later work like *In the Conservatory* (Plate 41) although simple in composition, looks overloaded with detail and fussily painted.

One might think that such an intrinsically attractive work as *Luncheon in the Studio* would have found favour with the critics and public, but in fact each new work by Manet which they saw incited them to mockery or rage. In the face of the fiasco of his one-man show in 1867, repeated rejections by the Salon jury and vituperative attacks in the press, Manet, who had hitherto alternated between extremes of optimism and pessimism, lapsed into a state of self-doubt and gloom. He virtually abandoned the stylistic synthesis which he had but recently perfected, painted less, destroyed an increasing quantity of works while still unfinished (Tabarant lists a mere six paintings done in 1867, and only seven in 1868), and no longer dared ask anyone outside his family and intimate circle of friends to pose for him.

At this critical juncture in his artistic development, Manet had only one consolation: a group of young admirers – Monet, Bazille, Renoir and Berthe Morisot – who hailed him as a great originator. He was friendly with all of them, but especially with Berthe Morisot. A product of the *haute bourgeoisie* like Manet himself, this intelligent and striking-looking girl appealed to him because she was an obliging model with dramatic, rather Spanish features and a habit of dressing in his favourite combination of black and white – as witness some of Manet's most hallucinating portraits (Plate 12). But because she was also a modern artist with a style of her own, she was in a position to teach Manet something as well as to learn from him. Amateurish and slapdash her work sometimes is, but her amateurishness was apt to be touched with genius. We must also not forget that she was a great-great niece of Fragonard, as well as an ex-pupil of Corot: hence her freshness of vision and lightness of touch, qualities which significantly appear in Manet's paintings in 1869. Berthe Morisot was not of course the sole cause of Manet's change of idiom at the end of the 1860s – Monet, an infinitely more inventive artist, was also partly responsible – but I suspect that it was she who persuaded Manet to look at nature with a fresh eye and who was responsible for discouraging his obsession with stylistic considerations. All things considered, it is hard to feel that the inspired amateurishness and proto-Impressionist approach of his Egeria had an altogether improving effect on Manet's art, for with one or two notable exceptions (e.g. *The Harbour at Bordeaux* (Plate 25) and the magnificent portraits of Berthe Morisot), the paintings of 1870–1 are sketchy and disturbingly eclectic in style. Had Manet been in better health or spirits, possibly his work would have been more vigorous and consistent, but the Siege of Paris, the Commune and the hysteria of post-war Paris life had left him in a wretchedly neurotic state. And the few paintings that date from this period of doubt and unrest reveal the artist wavering and seeking

inspiration alternately in the works of Berthe Morisot, Goya and Monet, reverting briefly to his own 'flat' style of the mid-1860s, then finally, after a visit to Holland in the summer of 1872, launching into a Dutch style *genre*-piece, the *Portrait of Emile Bellot* (Philadelphia, Museum of Art).

The *Portrait of Emile Bellot* is unique in Manet's *oeuvre*. It is more worked on than most, represents a deliberate attempt 'to make the critics swallow their words' – an attempt, it must be said, which succeeded, for when the picture was exhibited at the Salon of 1873 it was warmly praised – and lastly reveals the extent of Manet's temporary infatuation with the work of Hals and the Dutch *genre* painters. It also marks the end of a difficult period. Encouraged by having at last had a success at the Salon, by the fact that Durand-Ruel had recently bought a number of his paintings and, not least, by the gaiety which had returned to Paris with the Third Republic, Manet resumed painting scenes which would express some of the more agreeable aspects of contemporary life. Outstanding are *Music in the Tuileries Gardens* and *The Masked Ball at the Opéra* (New York, Coll. Havemeyer), a delightfully life-like *scène de moeurs* similar in composition and spirit to *Music in the Tuileries Gardens*. At the same time Manet found himself drifting more than ever into the orbit of the Impressionists. Here, however, we must tread carefully, for Manet's flirtation with members of this movement has been the cause of misunderstandings ever since the group was first dubbed '*la bande à Manet*' in the 1870s. Manet's stylistic discoveries, his rejection of a high academic finish, his use of pure colour and his naturalistic view of life had set an example which decisively influenced the Impressionists. But they owed no allegiance and over many fundamental problems, regarding the representation of light and optical reactions to colour, his views and theirs were diametrically opposed. The Impressionists were never in any real sense a '*bande à Manet*'; nor, as is so often claimed, was Manet in any real sense one of them. Manet never painted a truly Impressionist picture, that is to say one in which no black is used and colour is broken up into its complementaries, largely because he never visualized a scene purely in terms of light. For these reasons Manet always refused to exhibit with the Impressionists, preferring, as he said, to stand or fall on his own at the Salon. Manet was only an Impressionist to the limited extent that, under the aegis of Monet and to a lesser degree of Renoir, he took to using a lighter palette, painting in stippled and broken brushstrokes and experimenting more often than before with open-air subjects, for example in *The Grand Canal, Venice* (Plate 29). Far from harming Manet's art, the Impressionist influence had a most beneficial effect; his finest compositions of the mid-1870s – *Argenteuil* (Plate 28), for instance – are more homogeneous in handling, richer and more varied in *facture* and more brilliant in tone than those of the previous decade. Defects there are in some of Manet's work of the period – a falling-off in intensity and a tendency to indulge in *belle peinture* for its own sake – but these have nothing to do with Impressionism. On the contrary, they stem partly from ill-health, partly from discouragement in the face of the intransigently hostile attitude of the critics, Salon jury and public and partly, one suspects, from Manet's growing friendship with the poet Mallarmé (Plate 31) who seems to have encouraged the artist's latent aestheticism, his Elstir-like tendency to cultivate the exquisite.

By 1877–8 Manet and the Impressionists had drifted, artistically speaking, apart. Manet reverted to doing *plein-air* scenes during the last two years of his life, it is true, but all his really great late works depict not nature but mankind, and the female of the species in particular. Now it is interesting that Manet should

once have said that he never painted the quintessential woman of the Second Empire, but only of the Third Republic – interesting because at the very beginning of his career Manet already prided himself on being a 'painter of modern life'. Perhaps Manet would have painted life under the Second Empire more fully if he had felt less antipathy for the vulgar ostentation and totalitarianism of the epoch.

We have only to compare Manet with Degas to appreciate that whereas Degas shows us different aspects of an anonymous female animal – *l'éternel féminin* – Manet in his later works shows us the changing face of the Parisienne of the Third Republic – variously a courtesan, *grande dame*, actress, barmaid, bourgeoise, intellectual spinster and street-girl. What is more, he has taken care to see that the costume, coiffure and pose are appropriate to the sitter and typical of the time.

A chronicler of fashion? Yes, but also a chronicler of life. That is perhaps Manet's greatest quality. In his magnificent series of *genre* scenes of 1877 onwards – *Singer at a Café-Concert* (Plate 37), *Interior of a Café* (Plate 44) and *A Bar at the Folies-Bergère* (Plate 45), for example – one feels that Manet has somehow managed to stop the clock, for each of these works pins down for ever a moment of time in terms of great art. This is what distinguishes Manet from the lesser lights of his day – men like Tissot, Béraud and Stevens – who also set out to portray the passing show; this and the fact that Manet retained to the end his dispassionate and naturalistic vision. He always managed to see his period in perspective.

Manet's illness and premature death in 1883 were a much more serious blow for modern art than is generally realized. For, by the end of the 1870s, Manet had begun to take all kinds of daring pictorial liberties; had learnt how to obtain richer and more varied effects; had developed a more striking sense of colour; had considerably widened his imaginative range and had overcome his compositional failings. He himself seems to have felt that he was far from having nothing more to say, that, on the contrary, his best years lay ahead. And what is more likely? The Salon public was finally coming to tolerate his novel style and vision, and it is more than probable that popular success would have spurred him on to excel himself. *A Bar at the Folies-Bergère*, his culminant work, opens up tantalizing vistas of unpainted masterpieces, of a series of stupendous allegorical scenes of modern life which he envisaged.

Alas, instead of going on to paint more and more ambitious pictures, Manet was condemned by illness to work on an increasingly restricted scale – hence the impressionistic garden-scenes, the pastel portraits and flowerpieces of 1880–3 (Plate 48) – until in the last year of his life he seriously considered taking up miniature painting. This was Manet's tragedy – a more bitter tragedy, to my mind, than the blindness of Monet and Degas, more bitter even than the early deaths of Seurat and Toulouse-Lautrec, because each of these artists had been able to create an *oeuvre* that is homogeneous and complete. Manet was a great originator, a great executant, a great artist and a great influence; nevertheless the *oeuvre* which he left behind is, in the last resort, incomplete and only partly fulfilled.

List of Plates

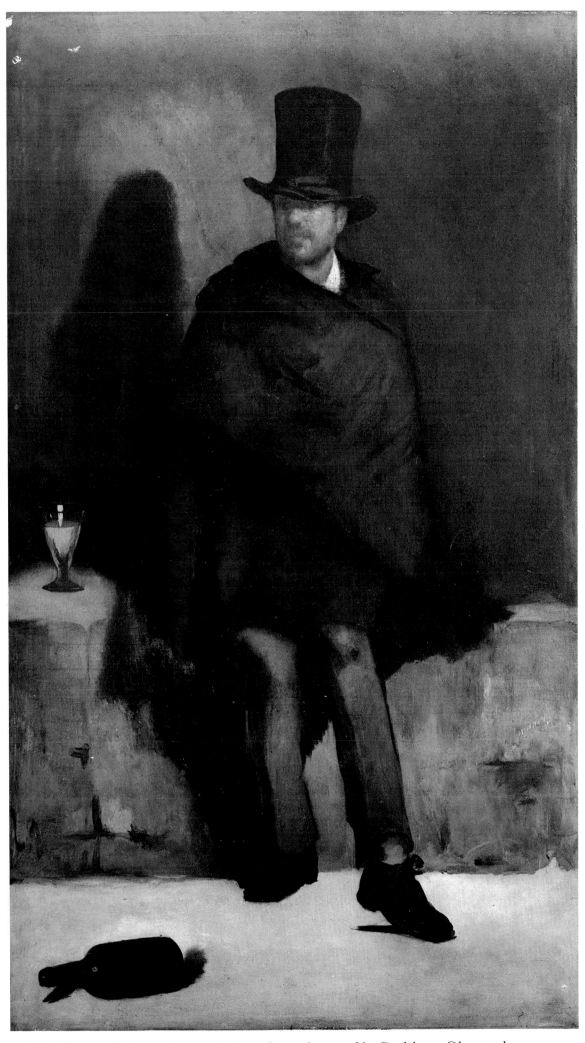

1. *The Absinthe Drinker*. About 1858–9. Copenhagen, Ny Carlsberg Glyptotek

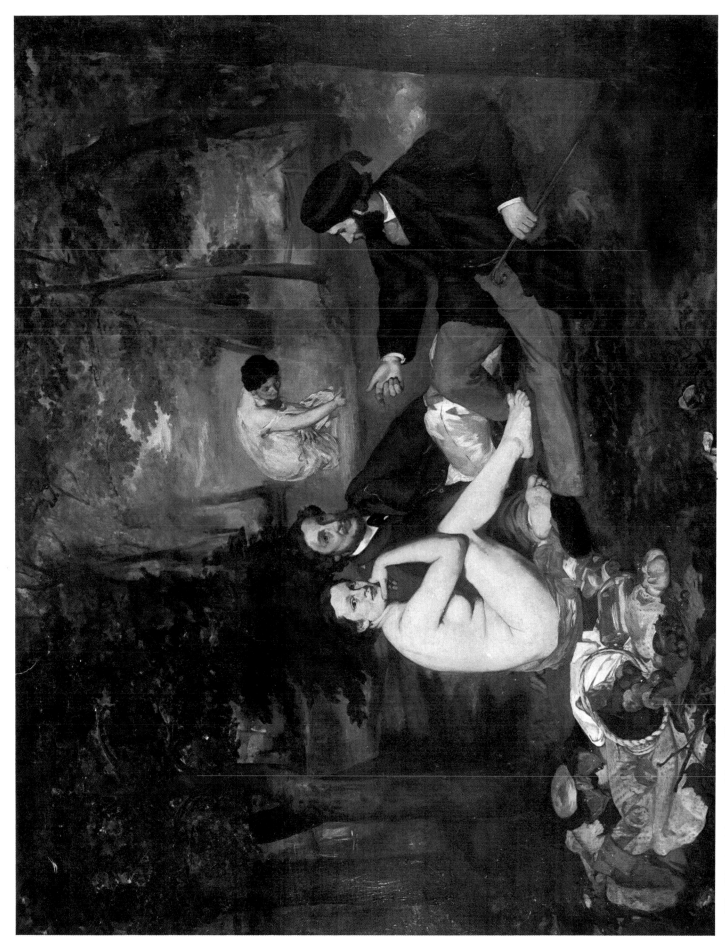

2. *The Picnic*. About 1862–3. Paris, Louvre

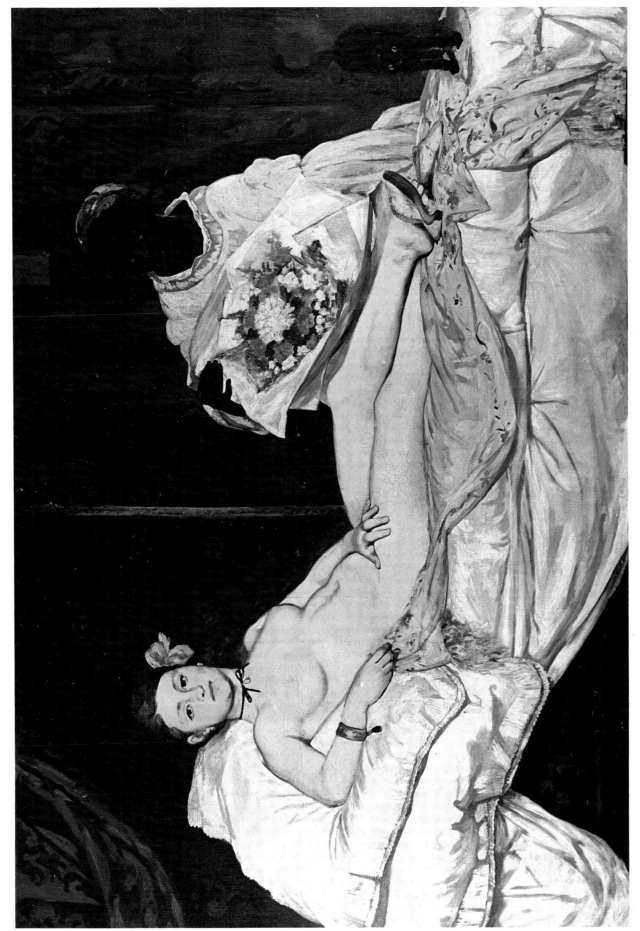

3. *Olympia*. 1863. Paris, Louvre

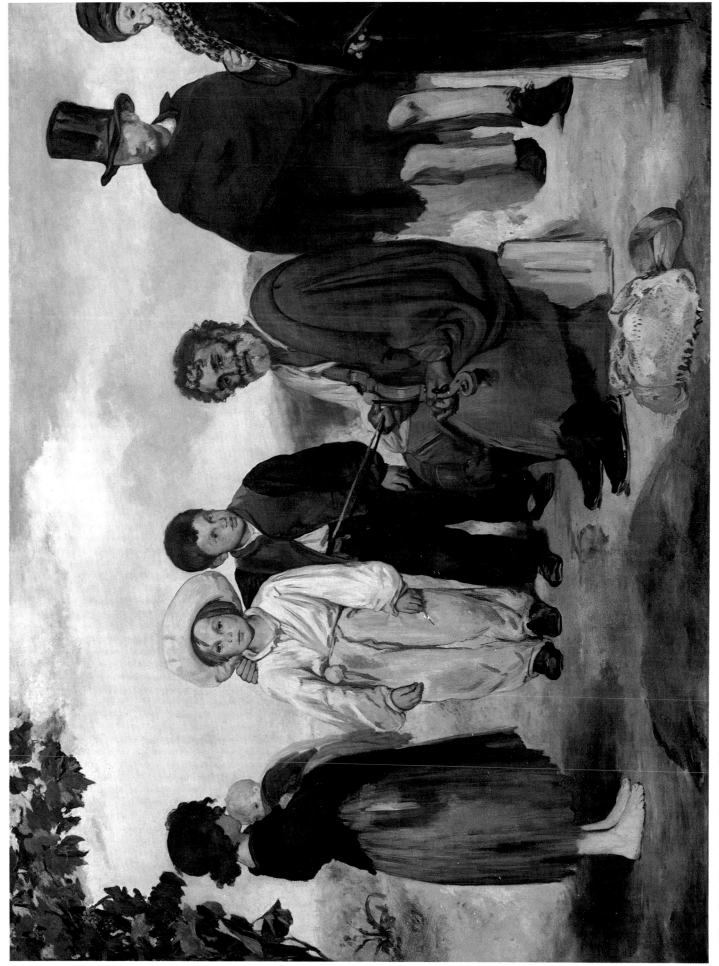

4. *The Old Musician.* About 1861–2. Washington, D.C., National Gallery of Art (Chester Dale Collection)

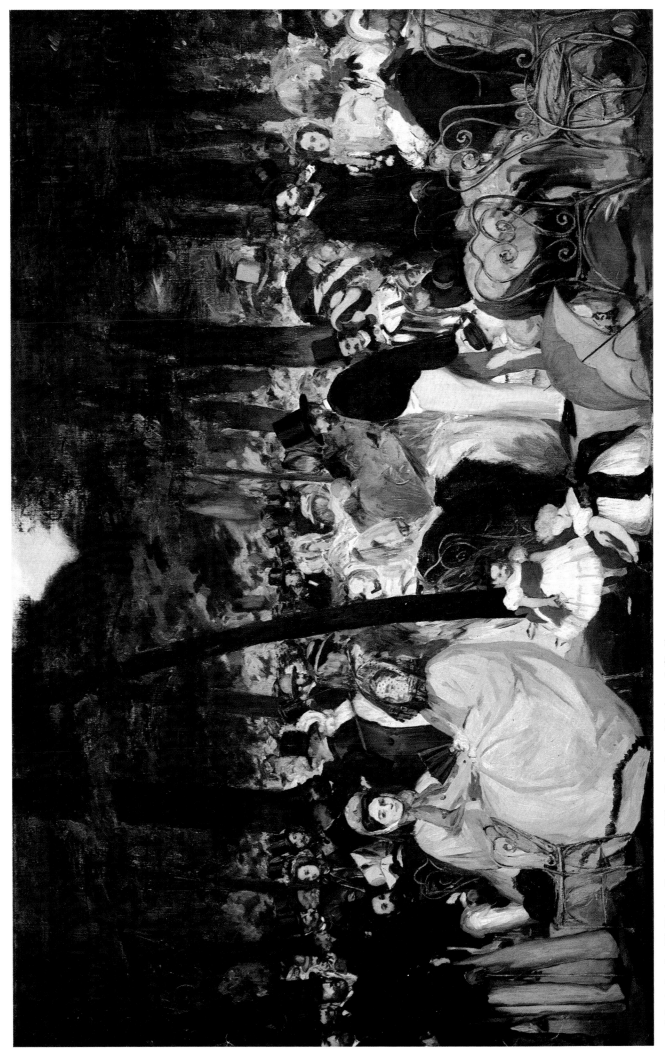

5. *Music in the Tuileries Gardens*. 1862. London, National Gallery

6. *The Street Singer.* 1862. Boston, Museum of Fine Arts

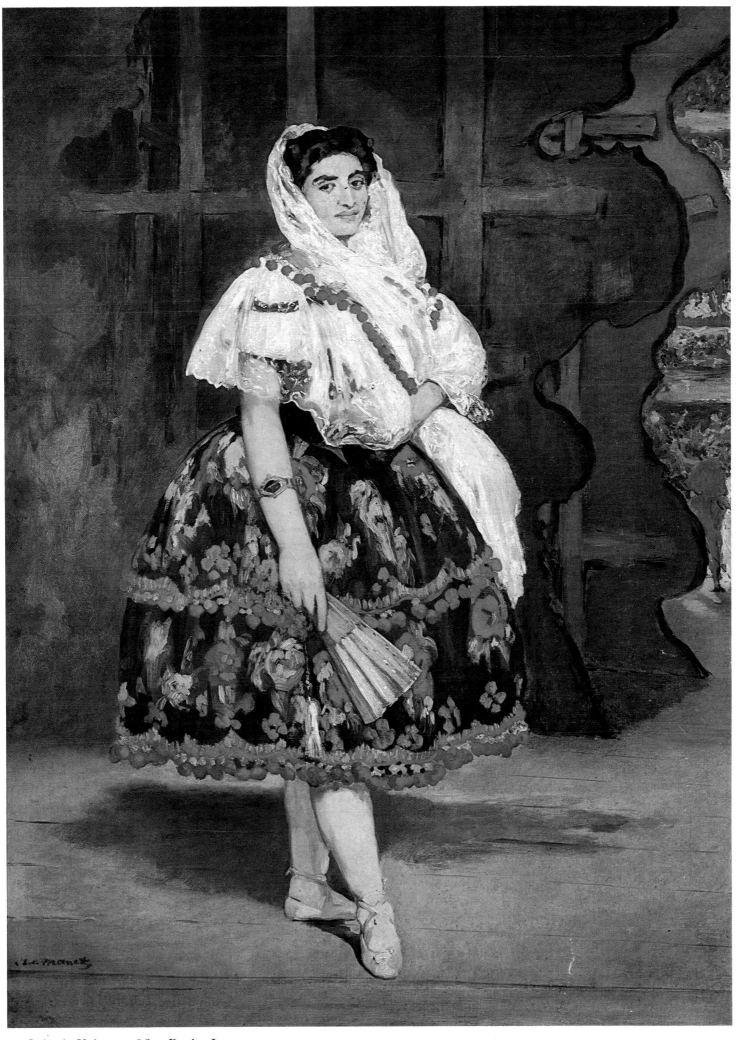

7. *Lola de Valence*. 1862. Paris, Louvre

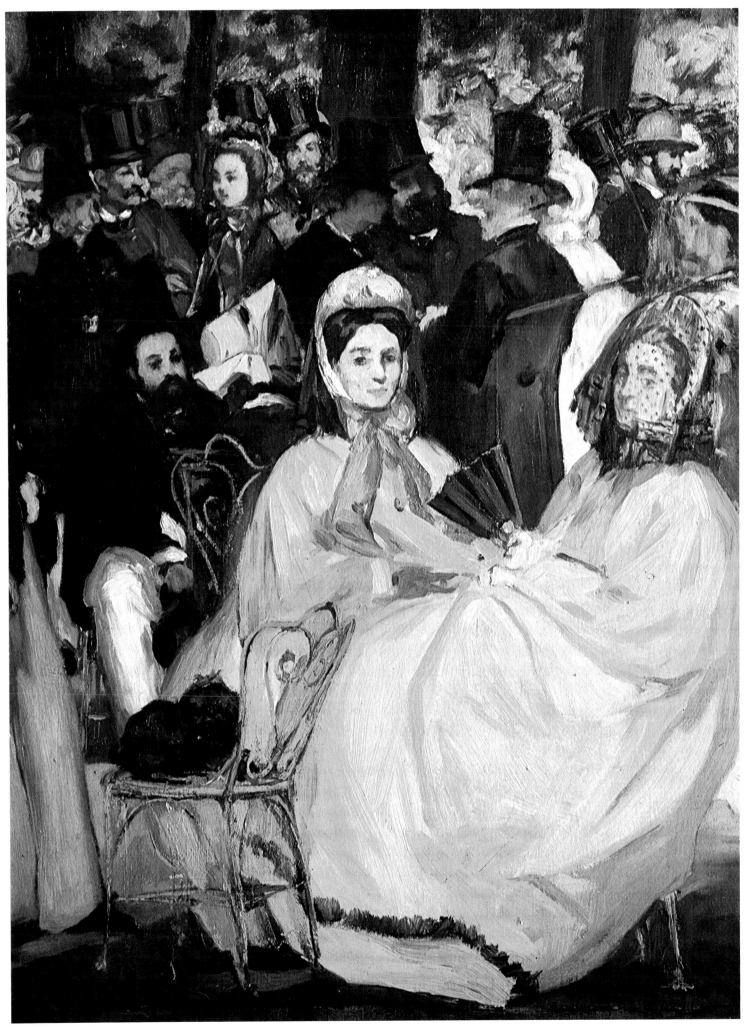

8. Detail of Plate 5

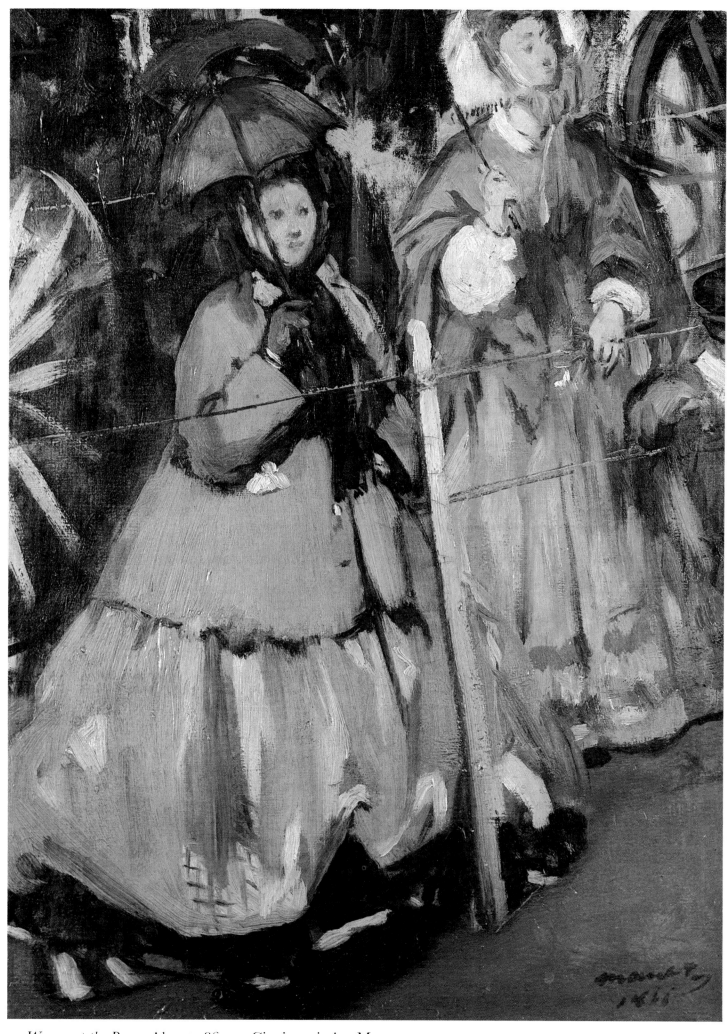

9. *Women at the Races*. About 1864–5. Cincinnati, Art Museum

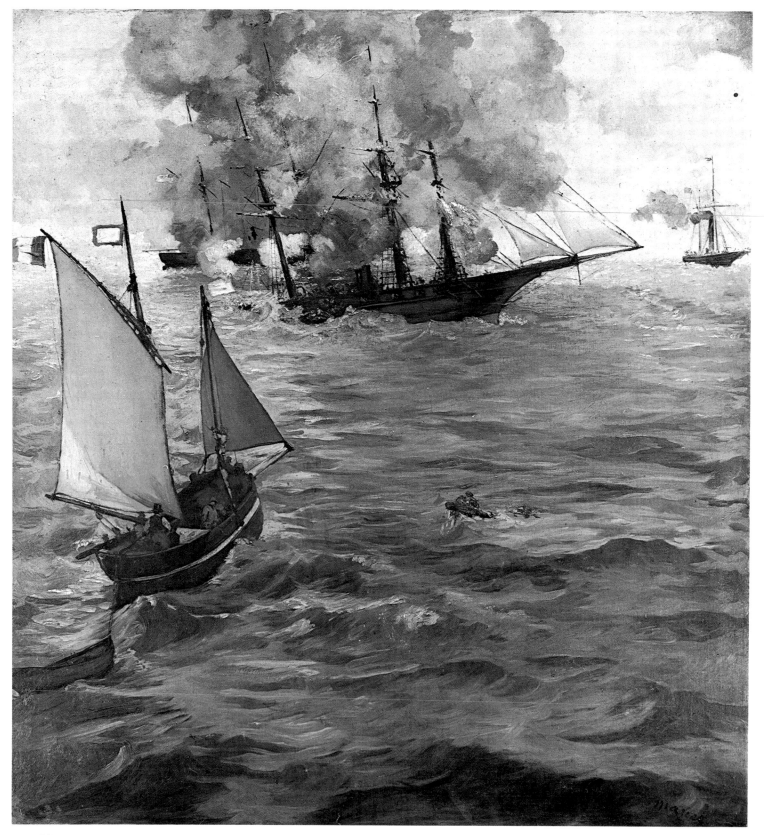

10. *The Battle of the Kearsage and the Alabama.* 1864. Philadelphia, The John G. Johnson Collection

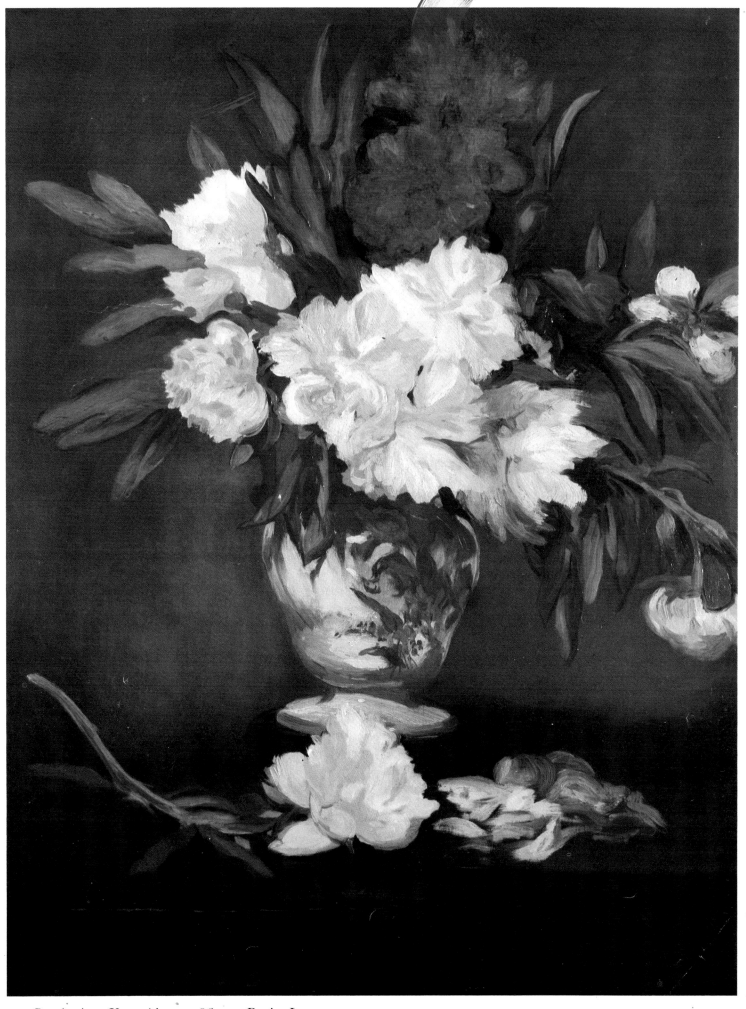

11. *Peonies in a Vase*. About 1864–5. Paris, Louvre

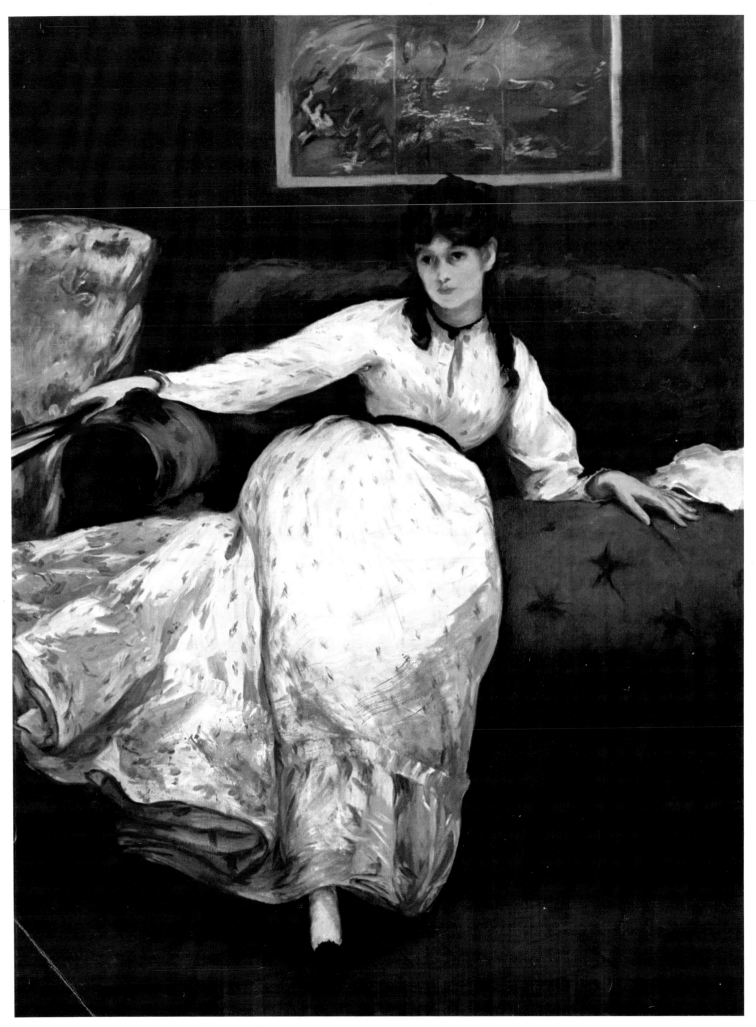

12. *Repose* (Berthe Morisot). About 1869. Providence, Rhode Island, Museum of Art

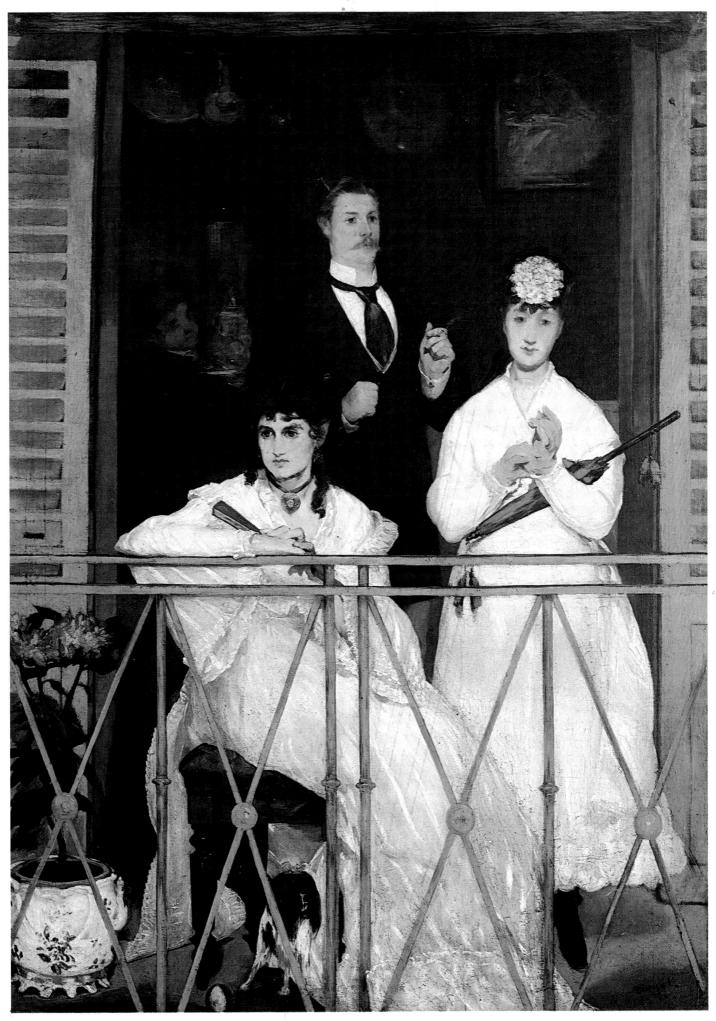

13. *The Balcony.* 1868. Paris, Louvre

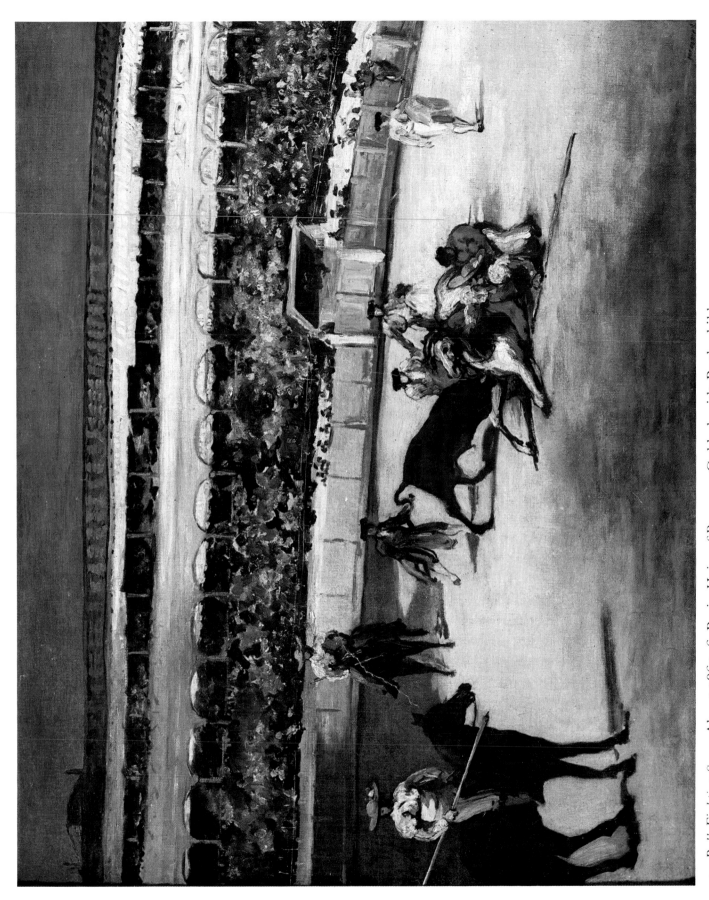

14. *Bull-Fighting Scene*. About 1865–6. Paris. Heirs of Baroness Goldschmidt-Rothschild

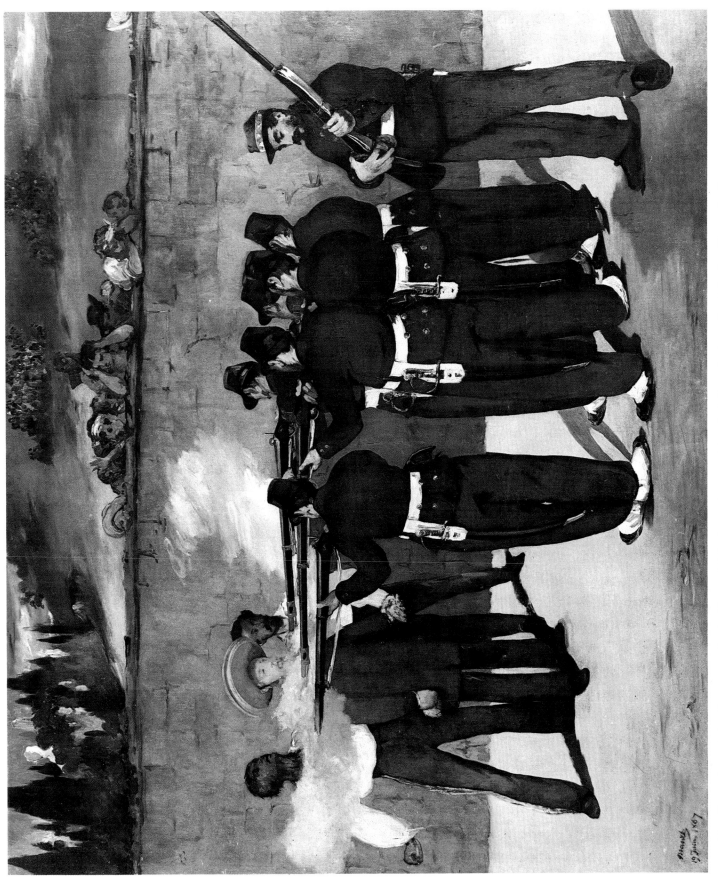

15. *The Execution of the Emperor Maximilian of Mexico.* About 1867–8. Mannheim, Städtische Kunsthalle

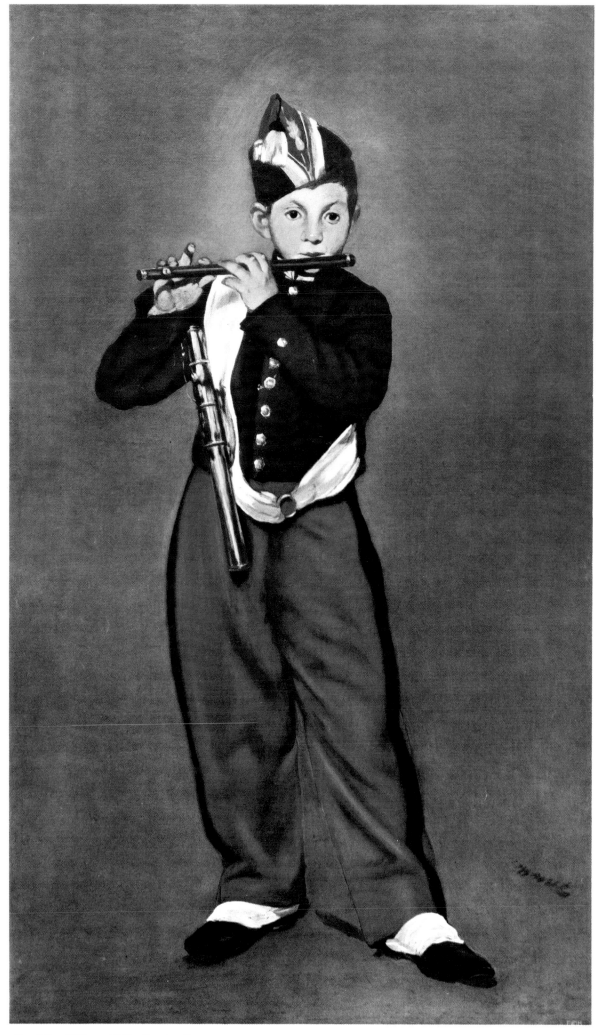

16. *The Fifer*. 1866. Paris, Louvre

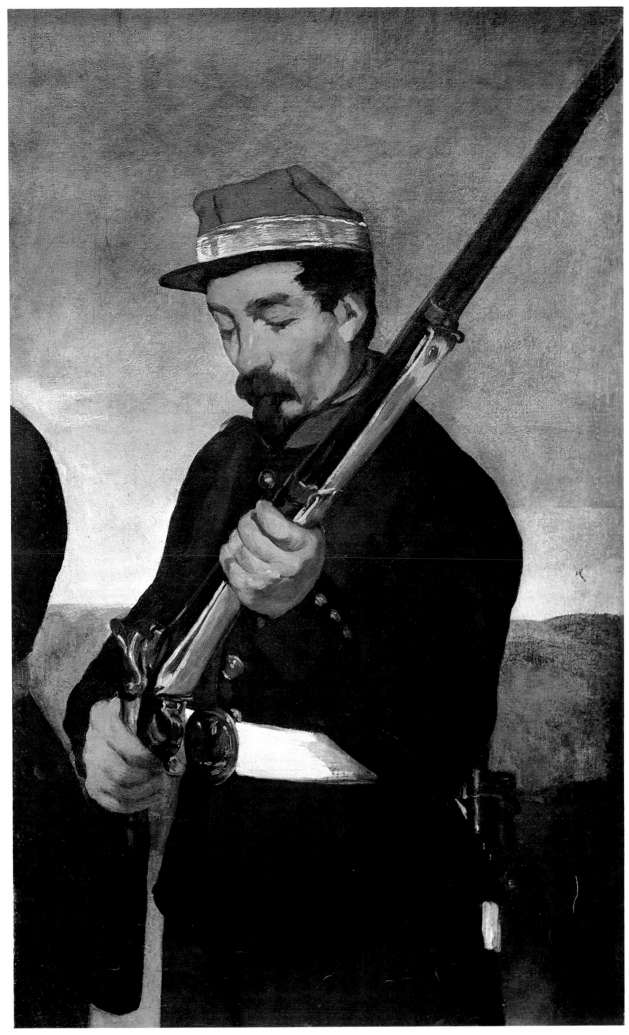

17. *A Soldier* (fragment from *The Execution of the Emperor Maximilian of Mexico*). About
1867–8. London, National Gallery

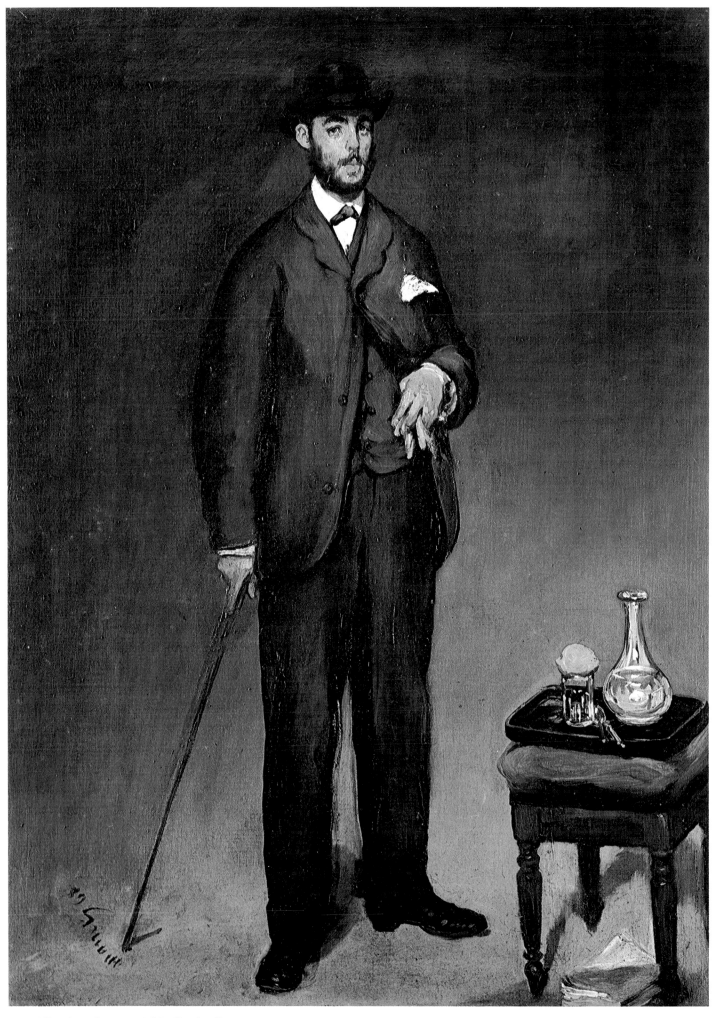

18. *Théodore Duret*. 1868. Paris, Louvre

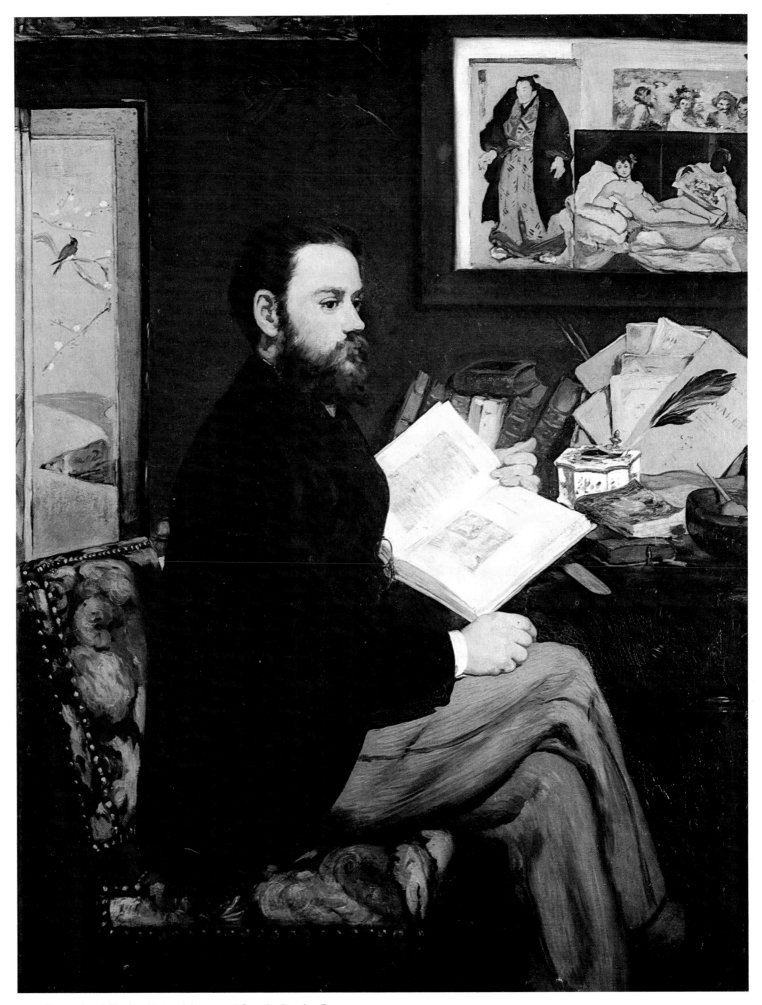

19. *Portrait of Emile Zola*. About 1867–8. Paris, Louvre

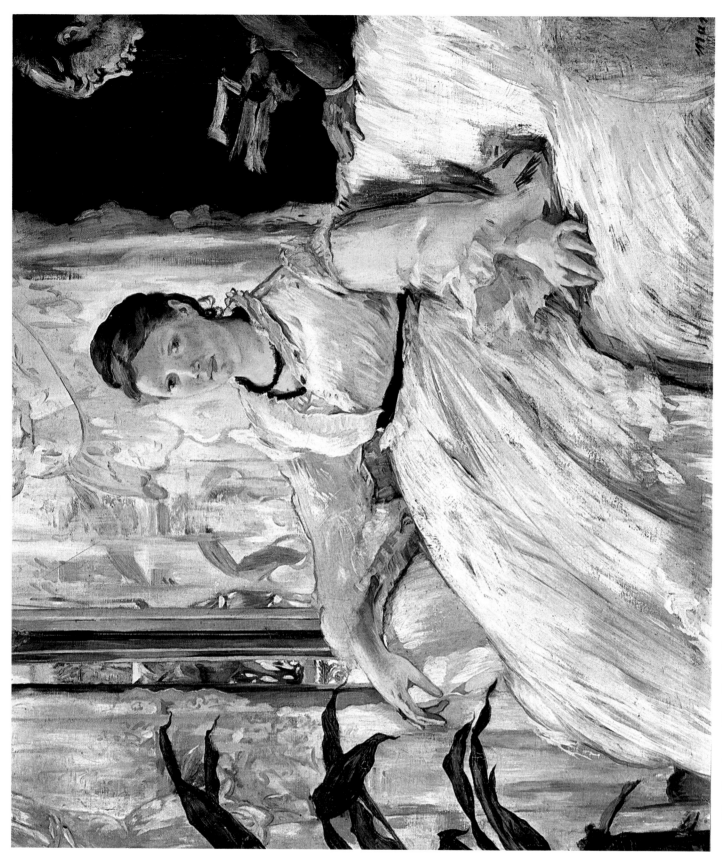

20. *The Reading.* 1869. Paris, Louvre

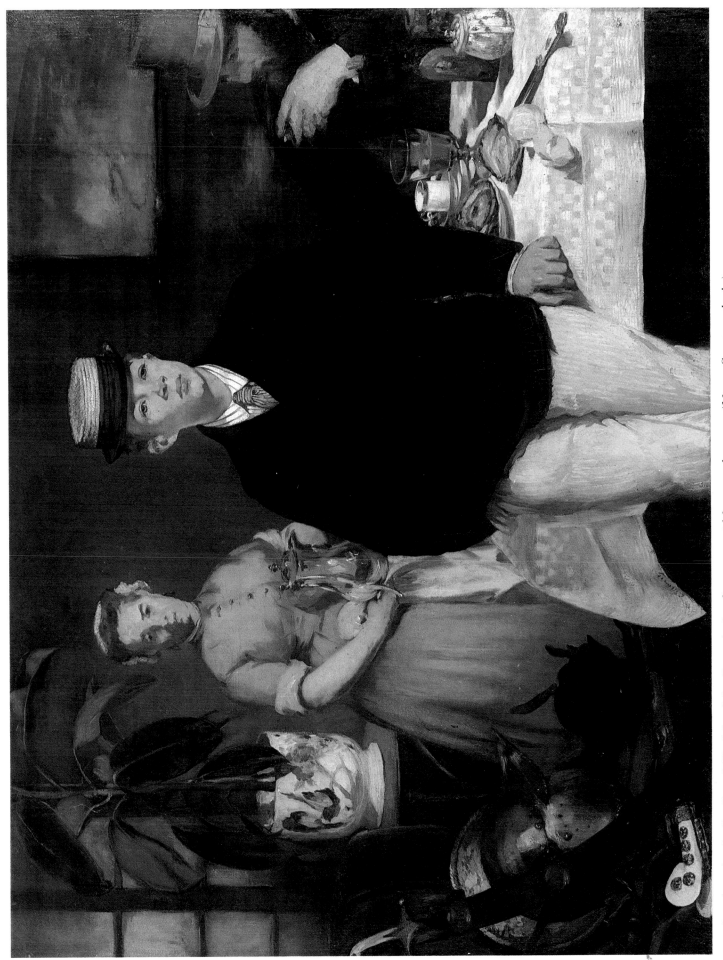

21. *Luncheon in the Studio.* 1868. Munich, Bayerische Staatsgemäldesammlungen (Neue Staatsgalerie)

22. *Eel and Red Mullet*. 1864. Paris, Louvre

23. Detail of Plate 21

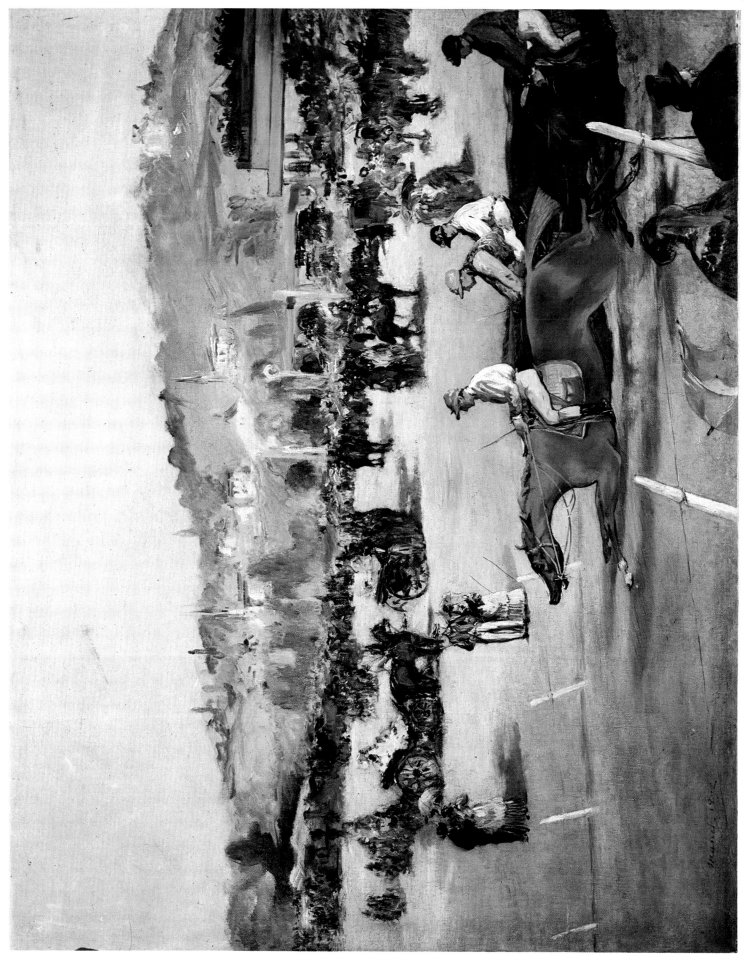

24. *Racecourse in the Bois de Boulogne.* 1872. New York, Mr John Hay Whitney Collection

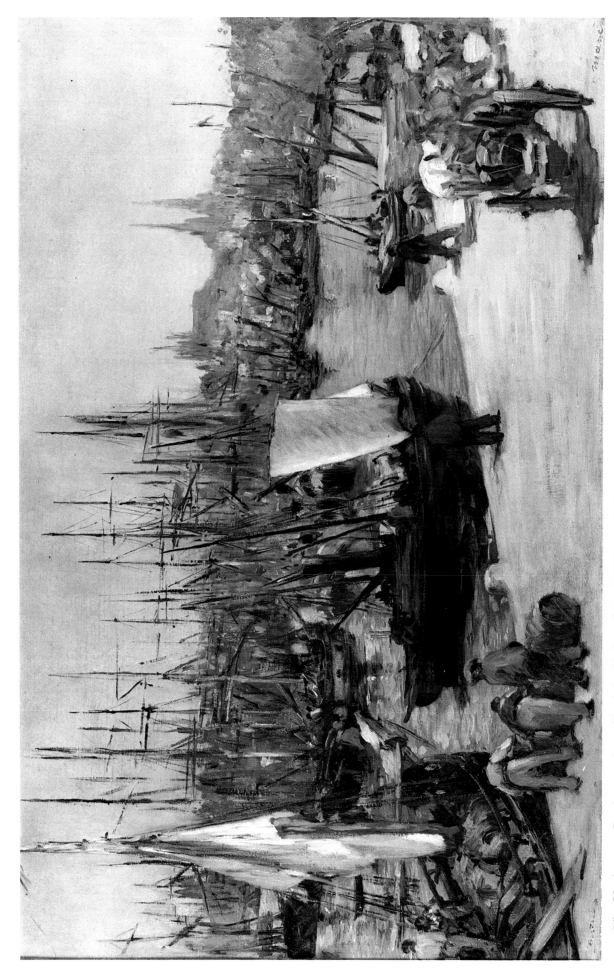

25. *The Harbour at Bordeaux.* 1871. Zurich, Heirs of Emil Bührle Collection

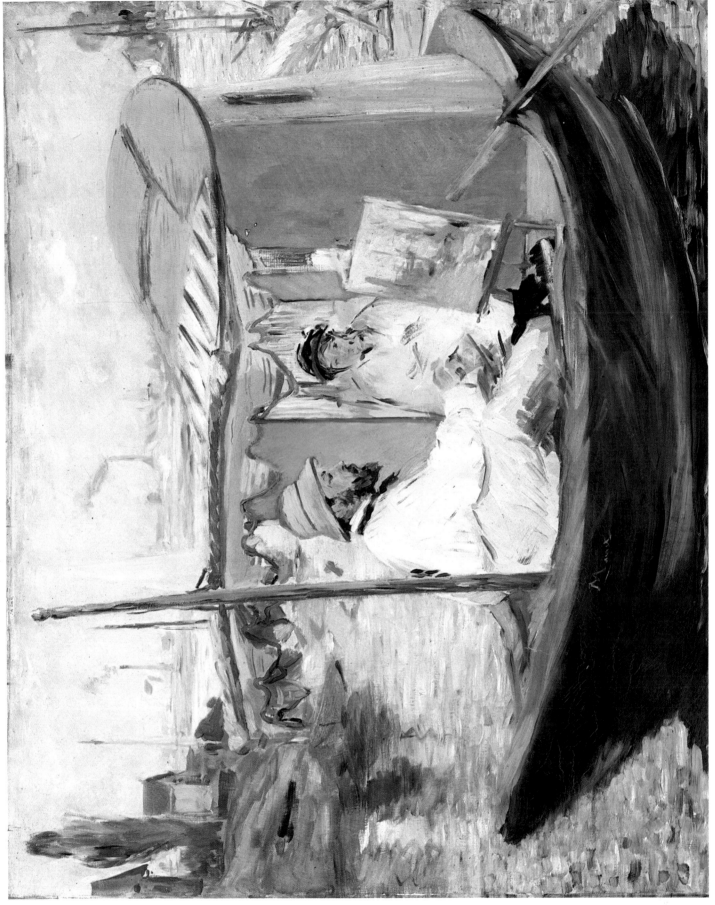

26. *Monet's Boat*. 1874. Munich, Bayerische Staatsgemäldesammlungen (Neue Staatsgalerie)

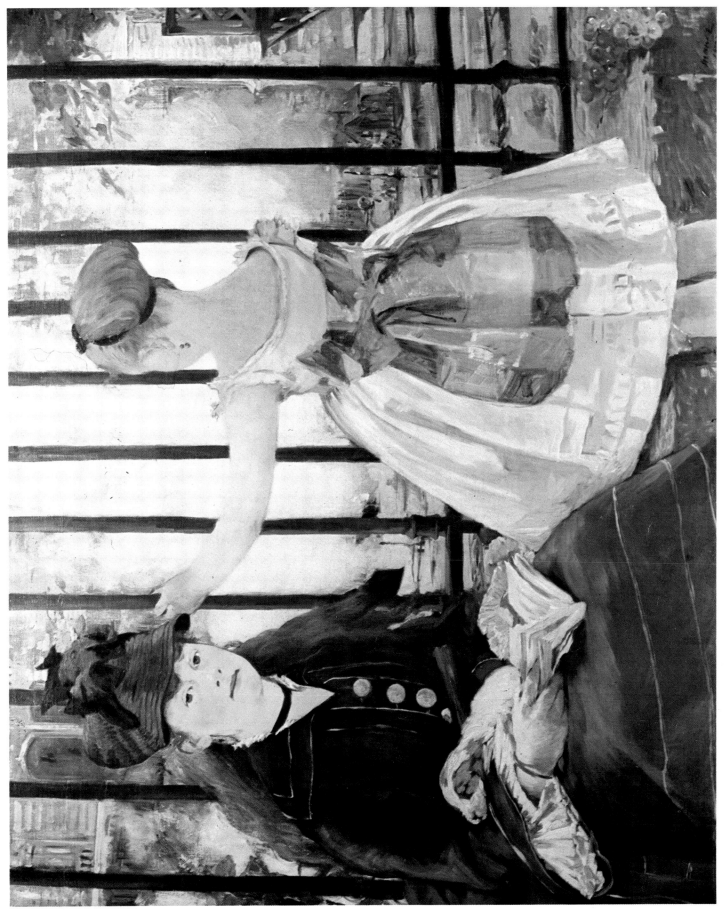

27. *The Railway*. 1873. Washington, D.C., National Gallery of Art

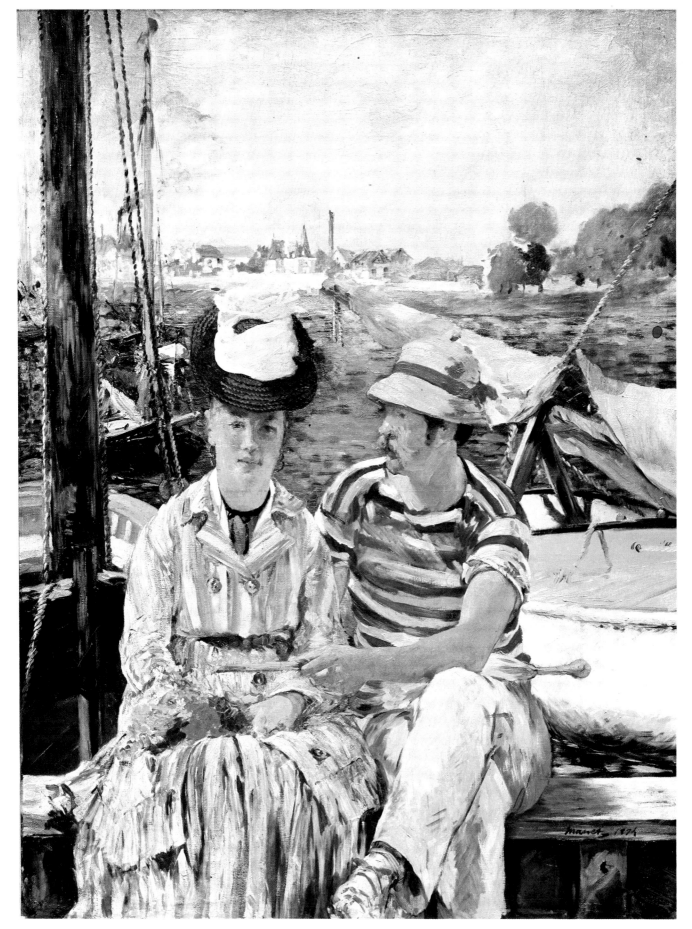

28. *Argenteuil*. 1874. Tournai, Musée des Beaux-Arts

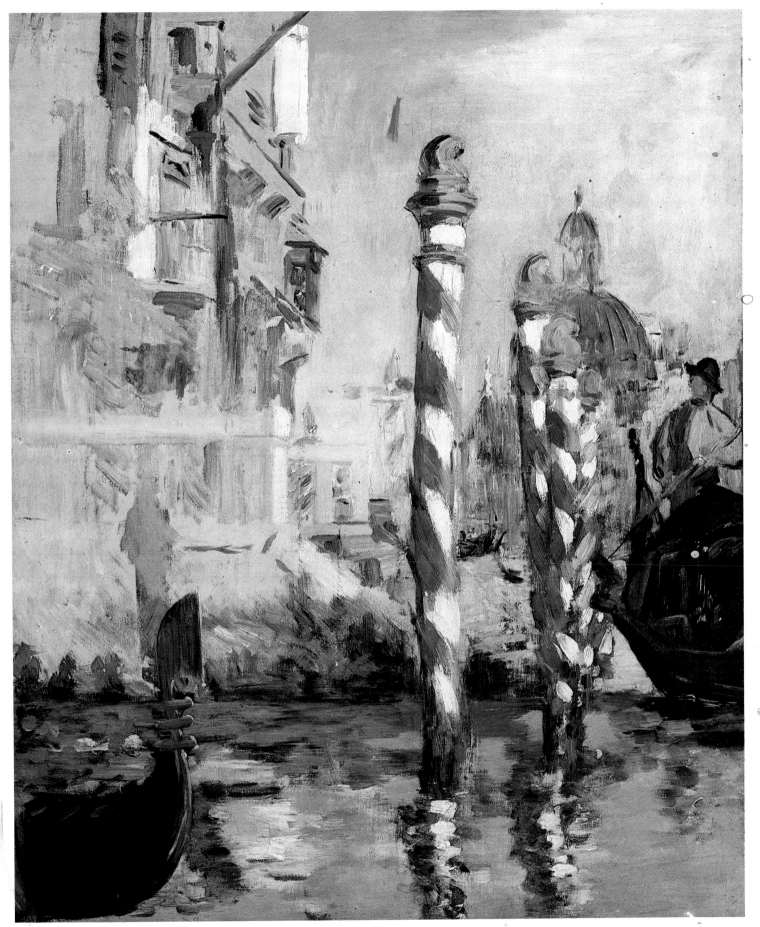

29. *The Grand Canal, Venice*. 1874. San Francisco, property of the Provident Securities Company

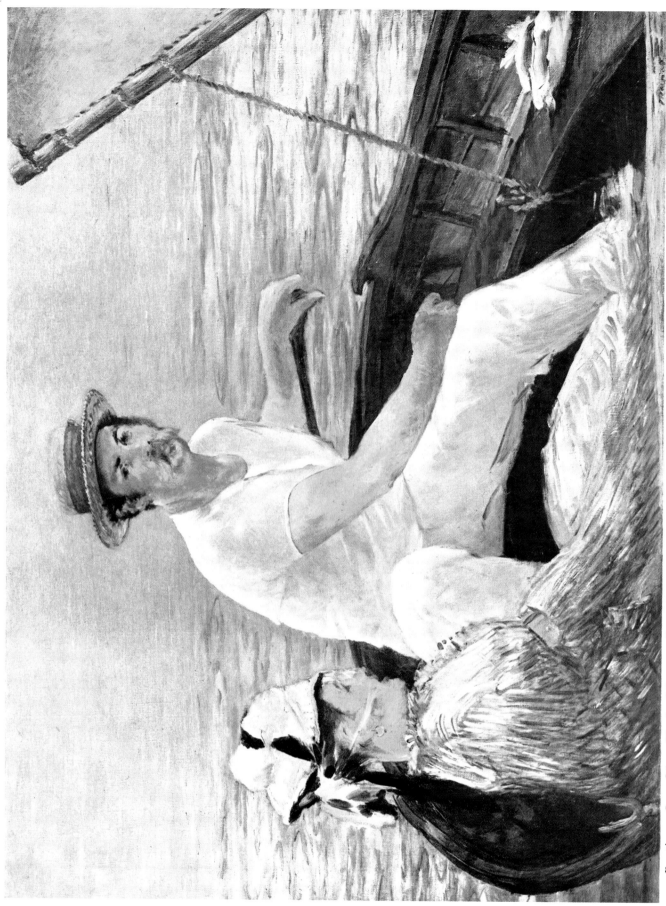

30. *Boating*. 1874. New York, Metropolitan Museum of Art

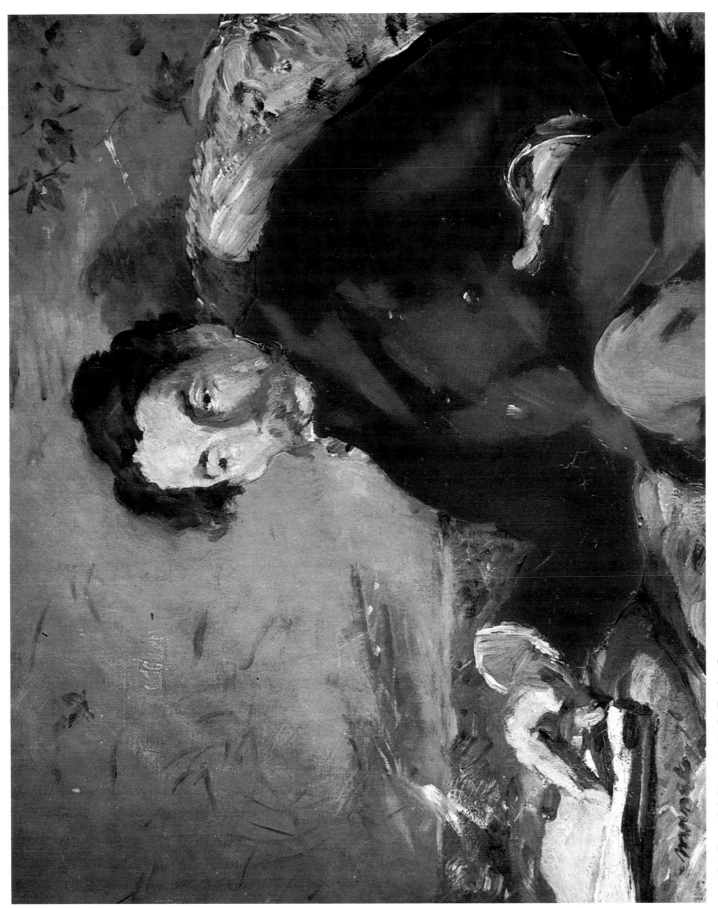

31. *Stéphane Mallarmé.* 1876. Paris, Louvre

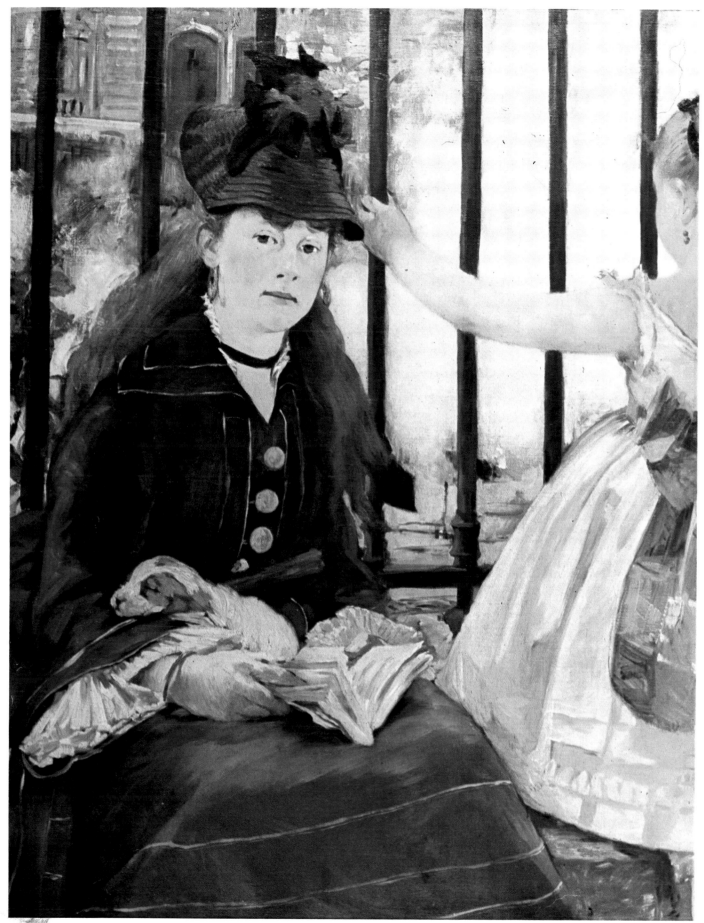

32. Detail of Plate 27

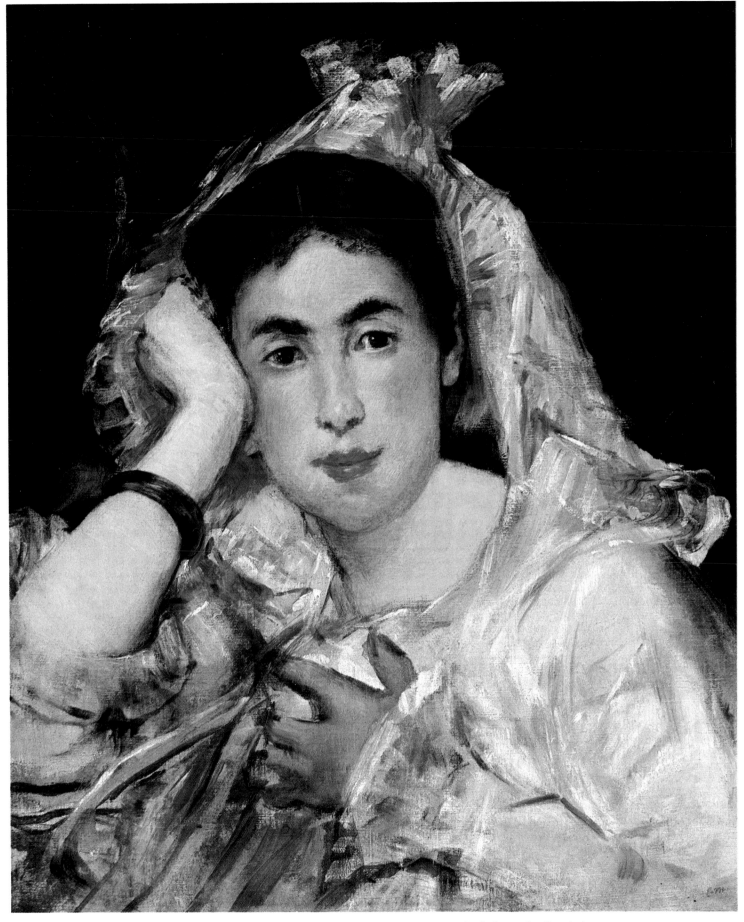

33. *Marguerite de Conflans Wearing a Hood.* 1873. Winterthur, Dr Oskar Reinhart Collection

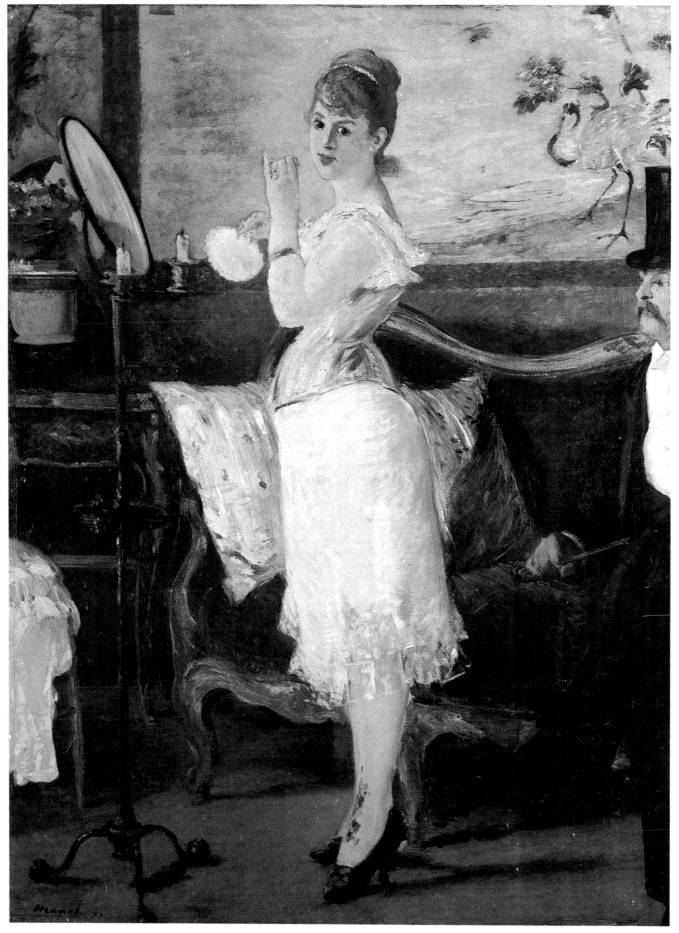

34. *Nana*. 1877. Hamburg, Kunsthalle

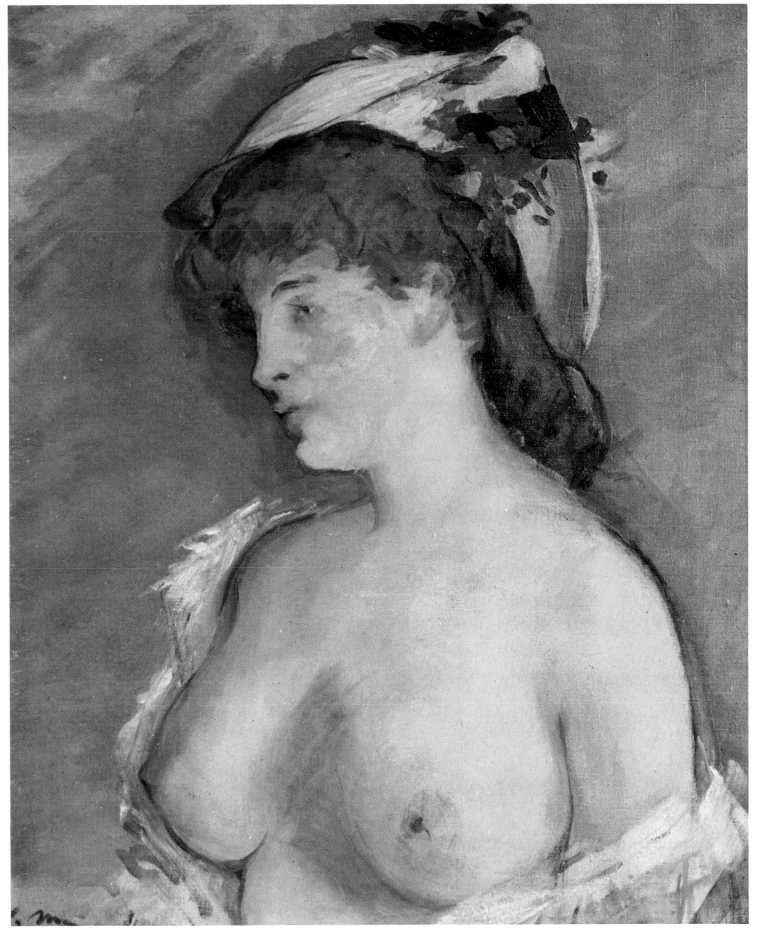

35. *Blonde with Bare Breasts*. About 1875–8. Paris, Louvre

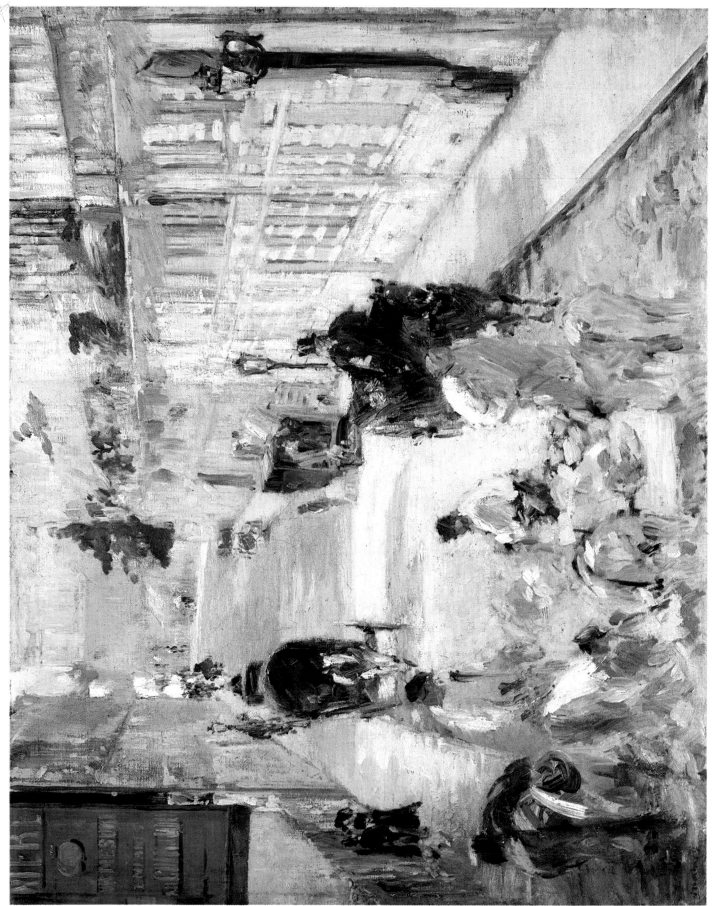

36. *The Road-Menders, Rue de Berne.* 1878. England, Private Collection

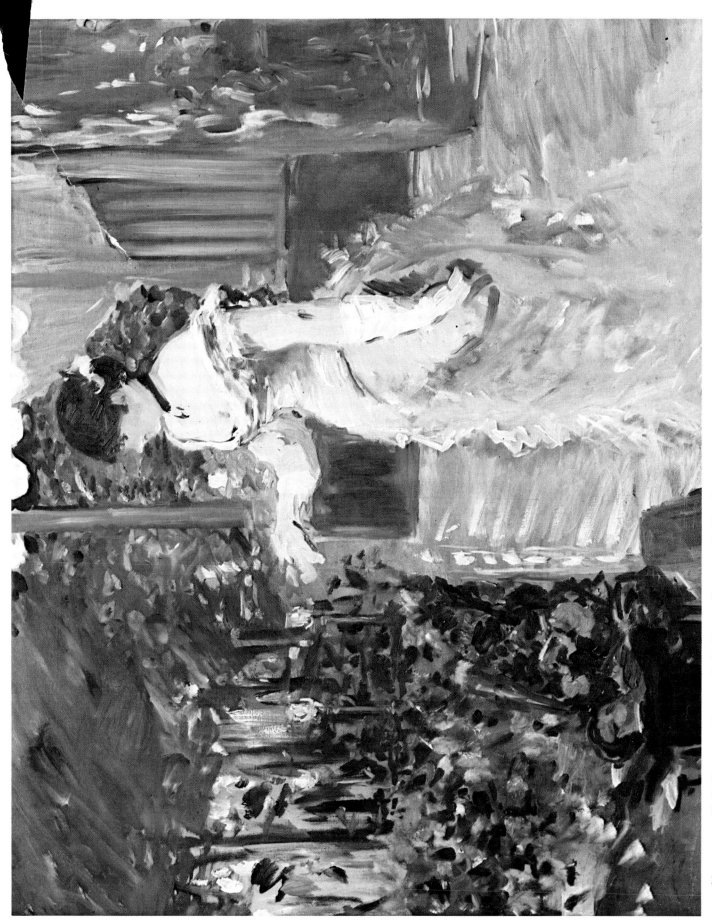

37. *Singer at a Café-Concert.* About 1878. Paris, Rouart Collection

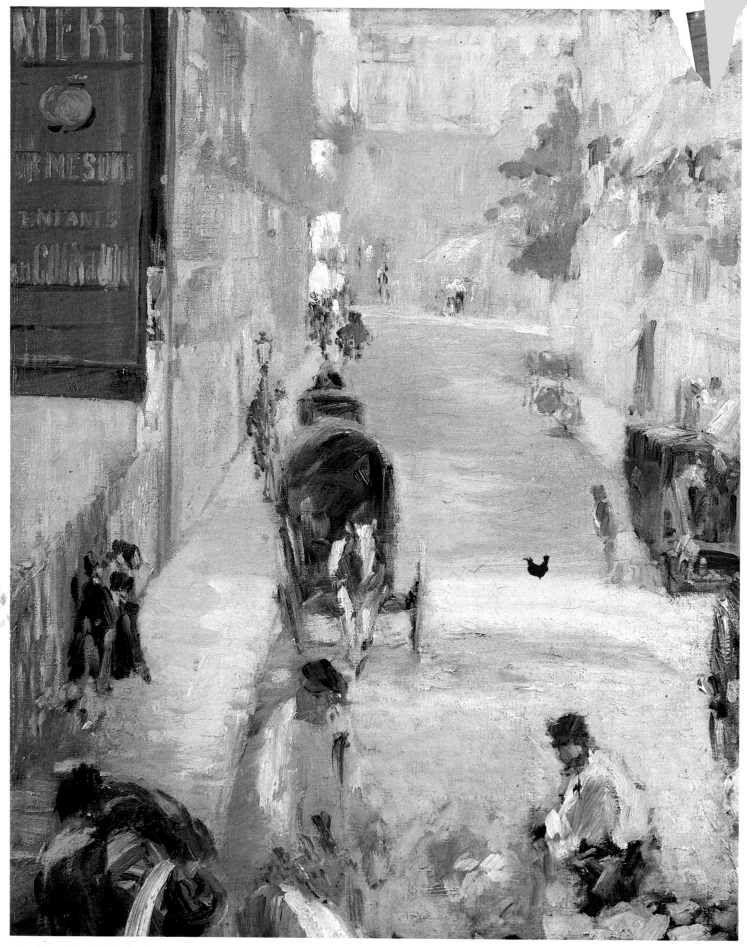

38. Detail of Plate 36

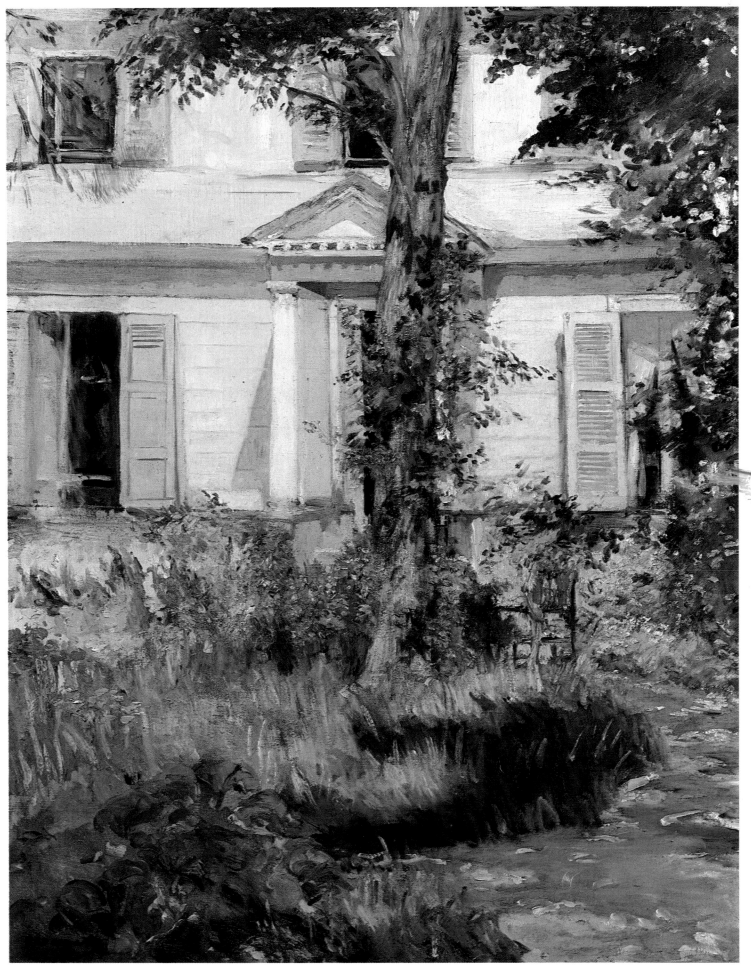

39. *The Villa at Rueil*. 1882. Melbourne, National Gallery of Victoria

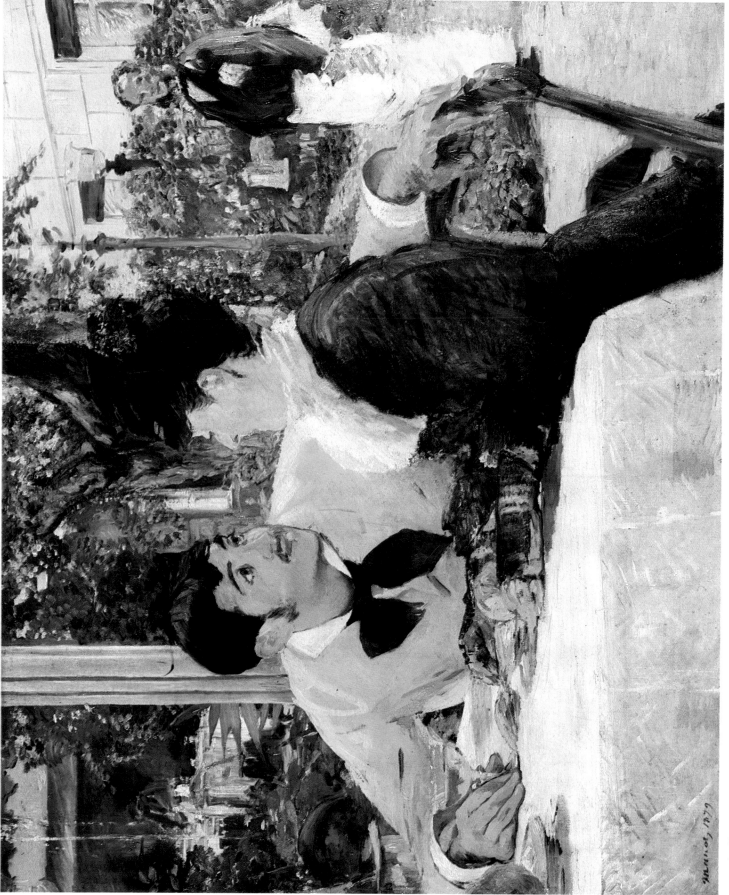

40. *At Père Lathuille's.* 1879. Tournai, Musée des Beaux-Arts

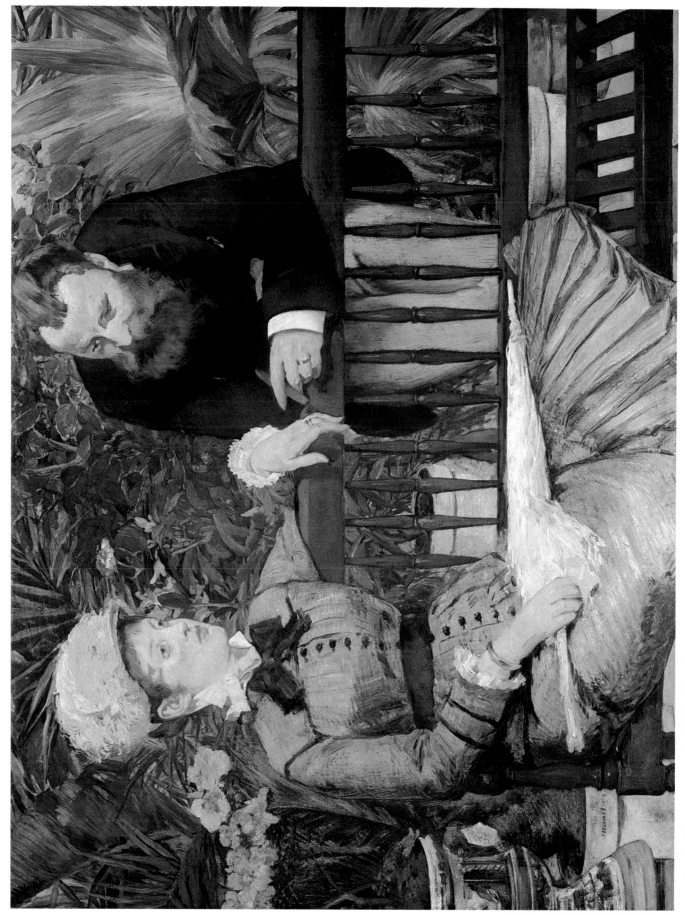

41. *In the Conservatory.* 1878. Berlin, Staatliche Museum

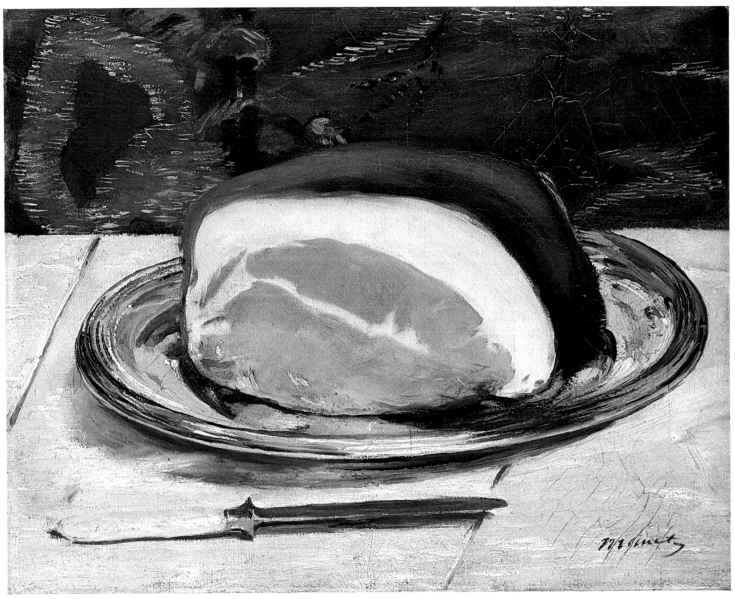

42. *The Ham*. About 1883. Glasgow, City Art Gallery (Burrell Collection Loan)

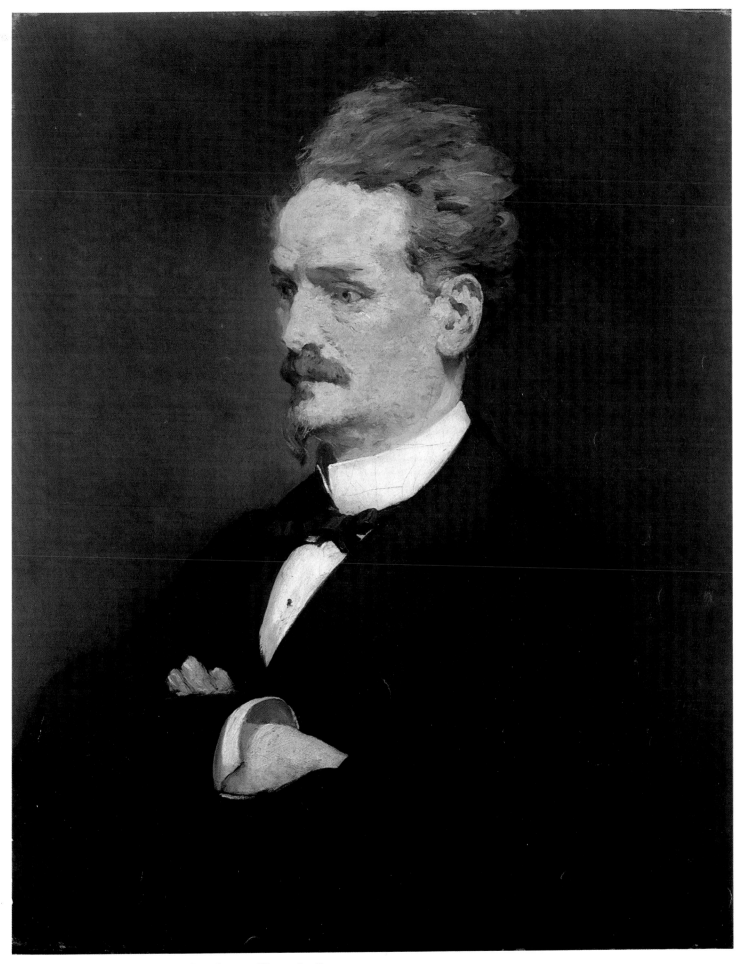

43. *Henri Rochefort*. 1881. Hamburg, Kunsthalle

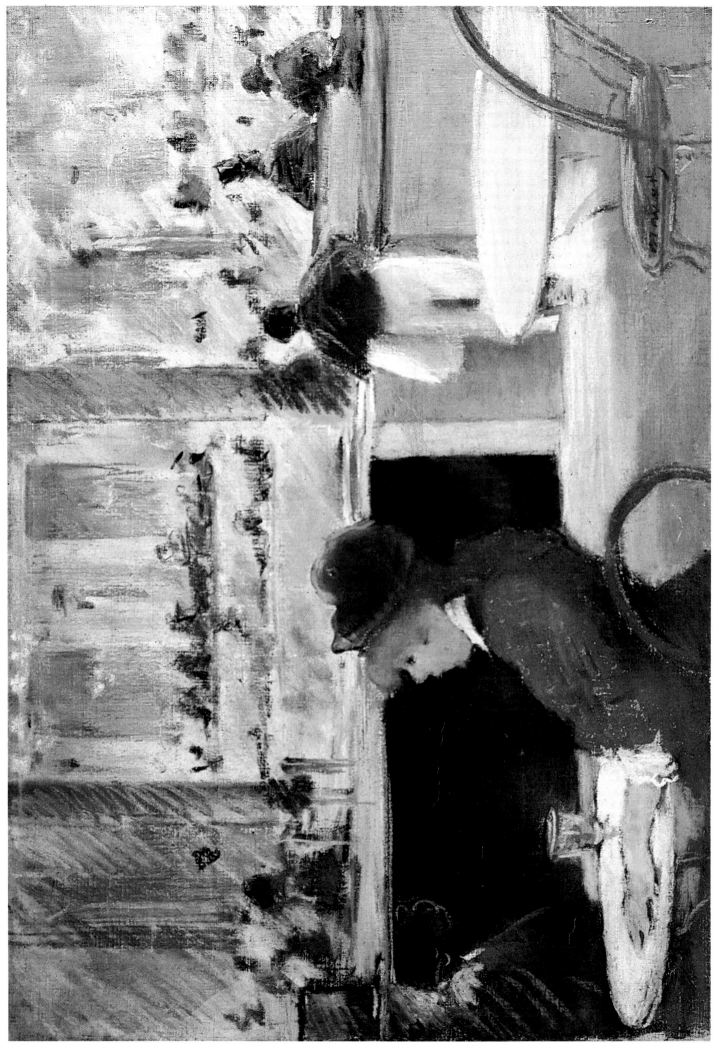

44. *Interior of a Café.* About 1880. Glasgow, City Art Gallery (Burrell Collection Loan)

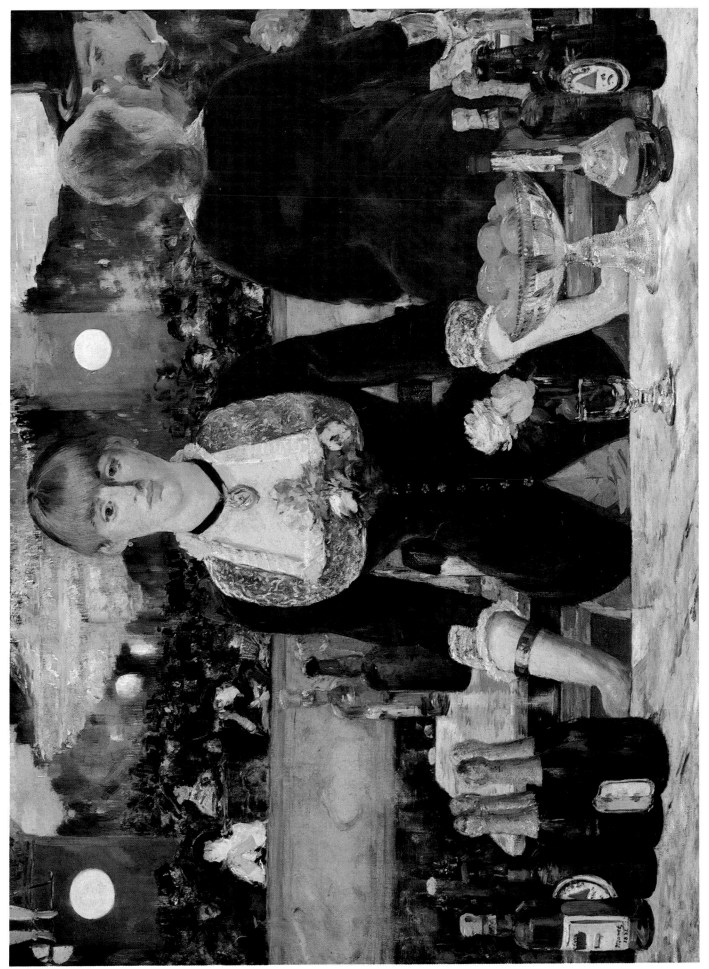

45. *A Bar at the Folies-Bergère*. About 1881–2. London, Courtauld Institute Galleries

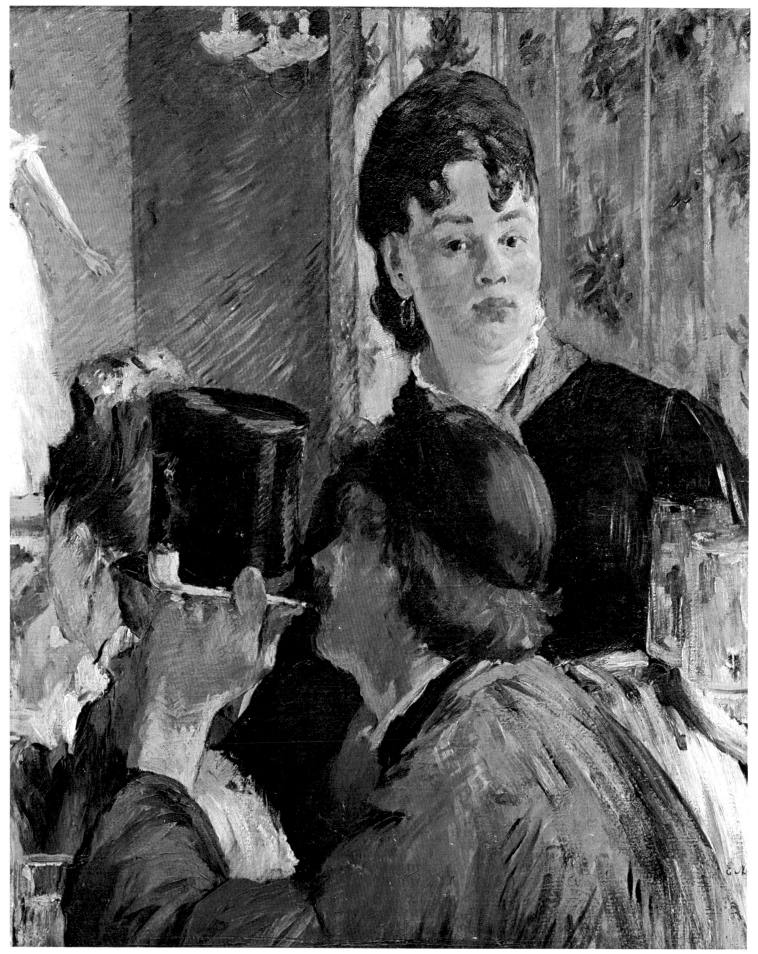

46. *The Waitress.* 1878. Paris, Louvre

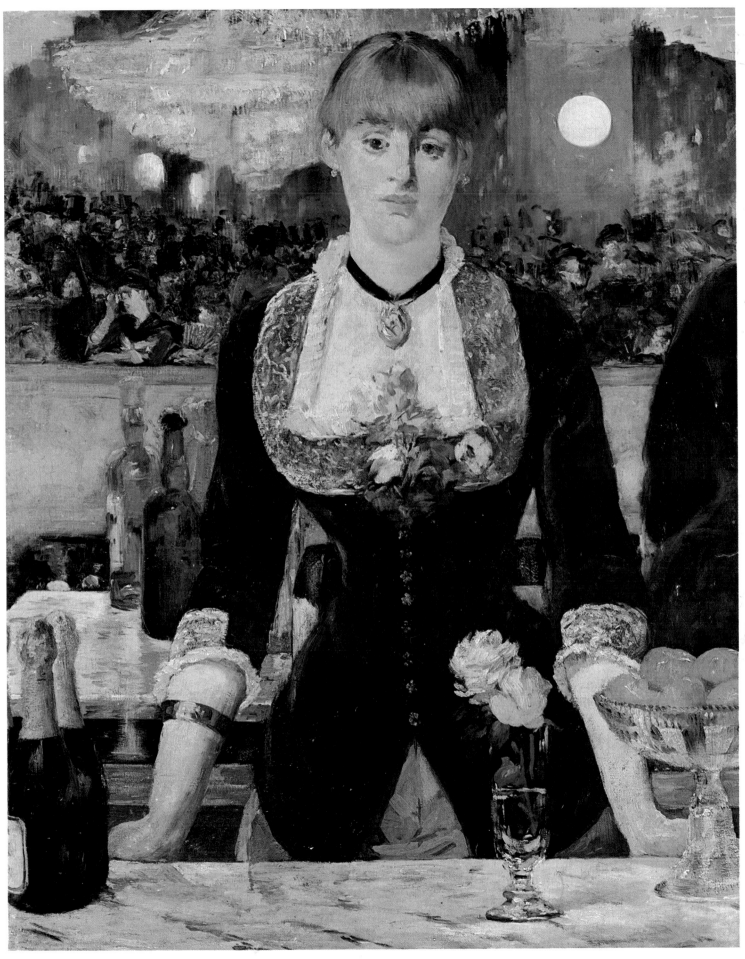

47. Detail of Plate 45

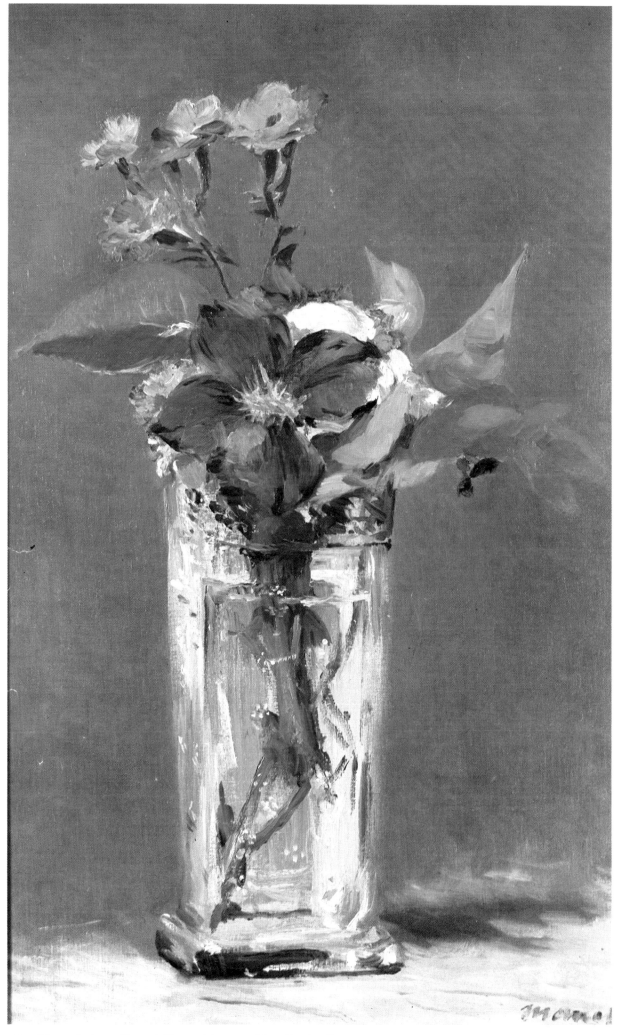

48. *Clematis in a Crystal Vase*. About 1880. Paris, Louvre